An Angel Named Sally and Two Guardian Angels

Marilyn (McQuiston) Graham

authorHOUSE®

AuthorHouse™
1663 Liberty Drive
Bloomington, IN 47403
www.authorhouse.com
Phone: 1-800-839-8640

Published by AuthorHouse 12/09/2014

ISBN: 978-1-4969-5814-3 (sc)
ISBN: 978-1-4969-5813-6 (hc)
ISBN: 978-1-4969-5815-0 (e)

Library of Congress Control Number: 2014921973

Special thanks to:

My husband Richard Graham for his support and encouragement.

Those who took time for interviews and provided extra help were:

Gary and Greg Graham
Bob Banta
John Devine
Pam Lewandos
Irene Otteman
Mary (Otteman) Fussman
Tim Otteman
Jeff McQuiston
Larry McQuiston
Linda (McQuiston) Dole
Bruce Murdoch
Gina Nelson
Reverend Ron Vredeveld

Contents

FOREWORD

This is my story of growing up in Central Michigan in the 1940's - 1980's where no programs were offered to developmentally disabled or challenged people. The "R" word is now considered unacceptable, thanks to more open minds, education, and public awareness. However, the offensive word "retarded" is used often, because it was accepted extensively during that period of time. Use of the word emphasizes differences in tolerance and compassion and how far we have come in the world today to diminish prejudices.

Marilyn (McQuiston) Graham

DEDICATION

This book is dedicated to my mother, Margaret (Dunkle) McQuiston, her dear friend Irene Otteman who devoted their lives to helping developmentally disabled people, and my sister, Sally McQuiston who was <u>Heaven's Very Special Child</u>.

HEAVEN'S VERY SPECIAL CHILD

A meeting was held quite far from earth! It's time again for another birth, said the angels to the Lord above.

This special child will need much love.
Her progress may be very slow,
Accomplishment she may not show.
And she'll require extra care
From the folks she meets down there.
She may not run or laugh or play;
Her thoughts may seem quite far away.
In many ways she won't adapt, and she'll be known as handicapped.

So let's be careful where she's sent. We want her life to be content.
Please Lord, find the parents who will do a special job for You.

They will not realize right away the leading role they're asked to play,
But with this child sent from above,
Comes stronger faith and richer love.
And soon they'll know the privilege given,

In caring for their gift from Heaven.

Their precious charge, so meek and mild,
Is Heaven's Very Special Child.

by Edna Massimilla[i]

MY LIFE GROWING UP
IN MICHIGAN

My family lived in a small town near upper Michigan. A welcome sign just as you enter city boundaries says "Gateway to the North."

Our family consisted of my parents, Margaret and Merrill McQuiston, four daughters, Janet, Marilyn (myself), Linda and Sally (whom the story is about) and one son, Larry. We were just like every other family except for having a child with Down Syndrome. During my lifetime things were much different and people were less tolerant of those who are diverse.

My sister, Janet, was only fourteen months older than I, and she was bossy as all get out. She was also the favorite and usually got her own way. My younger siblings either tagged along or I helped care for them when needed. We were a normal family with a small home, simple lifestyle, and many good memories.

We lived a serendipity kind of life and had so many opportunities that come with small town living and recreational activities existing on a lake. My parents didn't have a lot of money to spend on speed boats or recreational equipment, but we had a small row boat that sufficed. Many hours of pleasure were derived

from paddling around the lake, fishing or swimming to cool off on a hot summer day. Fish were never wasted. Instead, we brought them home, cleaned them and had fresh fish for dinner. They don't get any better than that.

Summers were hot and humid, but we were able to cool off in the lake just one block away. Although there was no beach on the shore near us, we found places where we could go. We all became good swimmers and enjoyed fun times on hot summer days just cooling off with a nice refreshing swim.

Our summer tans were dark and lasted half the year.

Winters were another story. Snow piled so high we had to stop and peek around the corner to watch for oncoming traffic. Icicles hanging from our roof eaves we could reach, break off, and lick like popsicles for a refreshing drink of water. The weather was very cold, but we walked over a mile to school and back every day. Neighbors did the same and our beagle hound went along to guard us from anyone or anything dangerous. We were much safer than today's youth who have to be anxious about terrorist attacks in malls, cyber attacks, identity theft, invasion of privacy, internet stalkers, exposure to violence, pornography, kidnapping, gunfire, dangers in school and dangers of human trafficking.

Spring rains came down like large bullets, but none of us had rain coats or umbrellas. We endured the water and took it in stride. Sometimes we were drenched by the time school started and everyone just sat in their wet clothes until they dried. The only ones free from it rode busses and lived far out in the country. Their bus rides were long and covered several miles. I was just a young girl. My two sisters always came along and we looked out for each other. Our little brother, Larry, was too young for school and stayed home.

Deer season came in autumn and crossing US 27 in Harrison, Michigan on our way to school and back was a big challenge that

lasted all deer season. Hunters from the city were headed up north across the great lake with high prospects of bringing back a deer. No courtesy was shown to children trying to cross the road and sometimes the wait would be long and weary. We frequently had to wait more than twenty minutes for a traffic break so we could wend our way to the school house. The deer hunters were bumper to bumper, lined up all the way to the ferry boats in Mackinaw City that crossed the water to St. Ignace in upper Michigan where deer were plentiful, the woods wild, and chances of getting a buck were excellent.

Today the ferry boats have been replaced by the Mackinac Bridge. The Mackinac Bridge is a suspension bridge spanning the Straits of Mackinac to connect the Upper and Lower peninsulas of the U.S. State of Michigan. Opened in 1957, the 8,614-foot bridge (familiarly known as "Big Mac" and "Mighty Mac") is the world's 16th longest in total suspension. The Mackinac Bridge carries Interstate 75 and the Lakes Michigan and Huron Great Lakes Circle Tours across the straits. The bridge connects the city of St. Ignace on the north end with the village of Mackinaw City on the south.ii

Deer populations were so large some animals would starve in the cold winters, so it was an act of mercy to control deer population. Many times one would be found almost starved from the covering of deep snow with grass hidden underneath. When found by local farmers they would pick them up and carry them to barns where hay or straw would nurse them back to health. Deer were killed and eaten by the average hunters, taken to local processing plants and cut into portions of steak, roast, ribs, ground meat, etc. They were not just for a trophy to be displayed by the average hunter. I remember two different uncles who nursed young deer back to health by feeding them bottles of milk. It was fun to watch them gulp it down.

Dad owned his own pipe fitting business. He helped build the local school we attended, worked on other local buildings, and did in-home projects for members of the community. The hardest part of business was collecting money once a job was completed, so he applied for a job as a Steam Fitter for Austin Company at Dow Chemical in Midland, Michigan.

Driving from Harrison to Midland was a long drive with hazardous road conditions during winter months. Michigan was fairly flat in comparison with the West Coast, but one place called James Hill was rather steep. Barrels of sand were placed on the road side so drivers could spread it on the road when needed. Harrison, Michigan to Midland, Michigan was 48 miles and took as many minutes on a good day. When it was snowing or icy driving conditions it took longer. He worked for them until retirement several years later and became a foreman overseeing the projects and other workers.

I can remember Mother often looking out the window and saying, "I hope he can get through James Hill." We were always happy to see him safely arrive home, especially in winter. It was necessary to get up early in the morning, drive 47 miles one way to work and the same distance back. Roads were only two lanes with no expressways. He always carried a lunch of warm soup in a thermos, a sandwich of homemade bread, and one of Mom's homemade pies. The soup came from vegetables dad raised in our carefully attended garden during the summer. Pies came from the fruit we all helped gather and canned in our own bottles. It was hard, sweltering, work in hot summers, but we reaped rewards in the winter when fresh fruit wasn't available.

It was always hot in the house from baking bread, canning, preserving, pickling, home cooking, etc. We had a nice family size picnic table that was located under the large oak tree and often had our summer dinner outside. Sweet corn and fresh vegetables

picked fresh right out of the garden surpasses any gourmet meal. One of my favorite meals was called "boiled dinner." It consisted of fresh vegetables boiled with a nice chunk of ham. Yummy! My, what a feast!

We had been attending a nearby church called The Highway Tabernacle and enjoyed friendships from the other children who were there. We participated in Christmas, Easter and Bible School programs. After services we would go outside and play games with the other children such as Mother May I?, Hopscotch, Tag, Simon Says, etc. We lived close enough to walk from our home. Mother always remarked how she enjoyed the minister's sermons. He moved to another area, was replaced by a new minister, and our new baby sister was born so we stopped attending church. Partly because Mother missed the minister, but mostly because she felt overwhelmed with the thought of getting five children and herself ready to go when Dad didn't attend. Dad would come see programs we participated in, but would quickly go outside and wait for the rest of us to join him and never wanted to chat with the other church members. However, when he grew older, Dad attended the Methodist church with Mother and Sally every week. He grew much more mellow and caring as years passed on.

The town of Harrison, Michigan was a resort town scattered with summer cottages and a few permanent homes. Summer brought people from the city looking for a nice vacation or those who stayed all summer and went back to the city when winter set in. One of those people was an older lady we called Aunt Gussie. We grew to love her like a grandmother. They lived near Detroit and had a nice cottage style home where they spent summers. She treated us like family. They raised a lovely garden of flowers and vegetables. Along the street where I walked to and from school were beautiful dahlias in assorted colors. Aunt Gussie was often out tending her vegetables and beautiful flowers. Some were as

large as a dinner plate and I would always pause to enjoy the splendor.

I loved my fifth grade teacher and would stay after school to see if there was something she needed help with. She would find little tasks like cleaning erasers, chalk boards or tidying up the room. All that changed when our little sister, Sally was born in 1948.

SALLY'S BIRTH

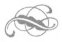

On the day Sally was born we were stopped on our way home from school by our neighbor. Aunt Gussie told us to wait at her house until someone came to get us. She served us milk and cookies plus the fun conversations we always indulged in. We weren't sure why she stopped us, but didn't question an opportunity to sit down and visit. After awhile someone came to get us.

What excitement we felt when we saw our new baby sister, Sally. No more staying late after school. I could hardly wait to get home to see her.

Babies were born at home and attended by the local physician. My aunt helped deliver some of the babies. There were no nearby hospitals in such a small remote town. We started helping care for Sally at a very young age.

The doctor told Dad that Sally was born with a birth defect called Mongolism more commonly known as Down Syndrome today. I'm not sure when Mother knew Sally was disabled, but Dad didn't say anything for a long time. Doctors advised parents of mentally challenged children to put them in an institution. My parents went against the tide and kept Sally at home

It was obvious something was wrong as her progression was much slower than other children. Someone older than myself would immediately recognize it in her delicate features, but we were young and didn't notice. As she grew older differences became even more obvious.

Just a few yards from our home was another house. We didn't know them well, but in the summers their two daughters who also had Down Syndrome would be brought home for a visit. They could be seen outside in the yard and we would watch with curiosity. We were now treated the same way. I could feel the intent looks as we were seen in public with Sally. My parents were one of the few parents who bucked the system and found their own way to cope. Her birth brought a new world of happiness, sadness, sorrow and searching they had never experienced. A long road was ahead that paved the way for others to find similar answers.

I'll never forget how I felt when Dad went to the local drug store where my peers hung out. She went along and followed him into the store unnoticed. When Dad arrived home she wasn't with him. I received a phone call from a fellow student telling me my sister was in the drug store. Dad jumped into the car and went back to get her. How uncomfortable I was. Even though we loved her, I knew how my peers felt. The gawks and stares were enough to tell me. Thank goodness things are better today and disabled people are acknowledged by the public. It is not uncommon today to see them joining in local activities. They are integrated in schools systems with programs that meet individual needs. Culture and traditions were so much different in former years when they were hid away somewhere and not seen in the community. Things have changed so much for the better. My mother, Margaret, was instrumental in helping escalate awareness and compassion for this special population. Because of her and other parents who wanted a better way, doors have opened for so many others.

I remember only one other developmentally disabled person who lived in our small resort town. His name was George. (name changed for confidentiality) and he was an adult with the mind of a child. Peers would tease him unmercifully, calling out to him, "Hey, George!" and play tricks that would make him hoot or yell. He was always in town when a parade or something else was going on. A local food store cleared their parking lot one evening a week for dances. We would go and watch. George would always be in the crowd and vulnerable to pranks. He was referred to as "retard" and treated as a big joke by a group of young men. That "R" word is now considered unacceptable thanks to more open minds and education of the public. Students on campus at Central Michigan University have a pact to totally remove the "R" word from their vocabulary[iii]

It was difficult growing up in communities where the disabled were never seen and we were so different. People would stare and whisper with inquisitiveness. We couldn't help but feel the unfriendly vibrations. I was always very shy anyway, and feeling so different from my peers was hard. I always had a great love for Sally, but at times resented taking care of her. Often I was the one elected while my older sister enjoyed our friends or family members. One example was when I took my classmate on a family picnic. I watched Sally while my older sister and our friend went off on their own.

Another time when our cousins and aunt came over to pick wild huckleberries. When we got out of the car, Mother said to me, "You stay here and take care of Sally." I answered, "I want to go, too." She wouldn't hear it and I ended up in the car with Sally while my cousins, aunt, sisters, mother and brother went off together to pick berries for hours. All but one cousin forgot about me. He came back to the car twice to say "Hi" and give a little bit

of company. Time stretched on and on while I sat there being the baby sitter while everyone else had fun being together.

Most of the time I was happy to help take care of Sally and we had a great relationship. She knew I cared for her. All of our family did and we always included her with holidays, picnics, birthdays, family reunions, weddings, funerals, church attendance, etc. Because I took care of Sally so often, we grew very close and she was always an important person to me despite what others thought. I knew her talents, personality, and kind heart. Sally was compassionate and kind to animals and people. We trusted her around our little babies when they came along, because she loved them and expressed only kindness, gentleness and affection.

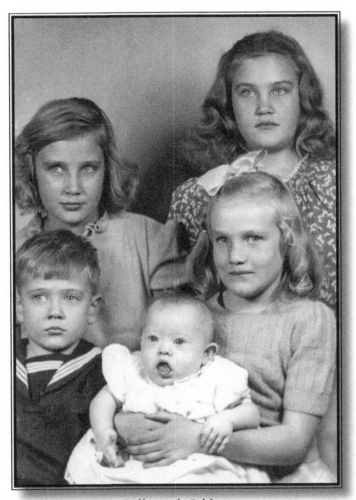

Sally with Siblings

Most people just didn't let anyone know they had a disabled child or family member during those days. It was undisclosed and they were hid away in rooms somewhere at home or in a state institution. There was no understanding of how teachable they could be nor anyone that had tried to work with them. Even an individual with epilepsy, cerebral palsy or any other disability would be shunned. The disease was considered something shocking and hidden. There were no medications like we have today to control problems.

I have spent countless hours wondering what caused her birth defect, Down Syndrome, which is the product of having one extra chromosome in each cell. Thoughts that have crossed my mind are many.

Was there an environmental problem that caused the birth defect such as water in Bud Lake where we fished and swam? Was there a contaminated well in our back yard where drinking water came from? Was it from the fish we ate that came out of the lake? Was there contamination from a vacant lot next to our home? (My sister, Linda, liked to go barefoot and would cut her feet on broken glass popping out of the ground from former debris.) Could former contamination cause a genetic defect that happened during her prenatal development?

Could it have been caused by the sulfa medication Mother took for bronchitis during pregnancy? I will never know the answer but I can't help but wonder.

Mother took Sally to visit many doctors, faith healers, and people in high places who made analysis of her condition. Nothing was determined and nobody had answers. Doctors found a heart murmur and said she would not live to be eighteen. Others said twenty-one would be the life expectancy. Sally lived to be fifty-eight years old.

Our home always had neighbor children coming over to play and we developed good friendships. They would be found in and out of our house, at the swimming place where we gathered, and walking to school together. After Sally was born they stopped coming. It was like we had a disease that might be catching and others would observe with lack of concern, the same as we used to do with the neighbors who had two daughters who both had Down Syndrome. People didn't understand that Sally's problem wasn't communicable or transmittable. They felt uncomfortable so we were isolated from many people. The segregation was the worst. Never mind the snubs and whispering. I could deal with it and pretend they didn't matter. It was like I wore a label on my back that said Quarantined or Contagious, Infectious Disease. Our small circle of real friends and many cousins, aunts, and uncles didn't care. They were our friends, no matter what and accepted her without question. My circle of friends were a select group of people who acknowledged our family for the value we were to our community and neighborhood. Neighbors, friends, and family who knew us well didn't let it interfere with our friendships.

My mother was a chosen person with great tenacity and a quest for her child to have a better life that was unsurpassed. I feel so proud of what my mother and father did to help these challenged people and want the world to know how choice they were. Most parents went the usual route and put their handicapped children in institutions where they would rarely be seen, but our family was different. Sally was part of everything we did and wherever we went. My classmates all had seen her around town and knew of her existence. I didn't pay a lot of attention to what anyone said, because those that really counted accepted Sally and me. There were times when I hurt deeply because someone had said something mean, but life went on and they were just crossed off my list of associates. I learned early in life to value those who

were true friends and not be part of a chosen popular group. My relatives were really my best friends.

Mother grew ill when Sally was just a couple of months old and had to be hospitalized. Fortunately, Dad's sister was visiting from Detroit and took care of Sally, got us off to school, fixed our meals, and did daily chores during the crisis. We didn't realize it at the time, but nobody was hospitalized unless it was very complicated and serious. The closest hospital was in Gladwin, eighteen miles away on country roads.

As I recall the dense fog, the fog lights Dad attached to the front of our car with wires so he could see on dim roads, and the long distance on dark roads in precarious weather, I understand more fully what was anticipated. Dad had lost his mother when only twelve years old and this must have been a gloomy time in his life, recalling his own loss at such an early age. He was a man of few words, but such thoughts must have come to mind. Four of us children piled into the car with Auntie staying behind to care for Sally. Dad didn't talk much, but he only told us where we were going. We arrived at the hospital and were allowed to visit briefly. He told us all to kiss her goodbye. Little did I know that she was not expected to live. Family members were not normally allowed to visit in those early days with the exception of spouses. Our visit of four children was surely an exception to the rule. I later learned she had an unfavorable reaction to anesthetic and was not expected to live.

Fortunately for all of us, especially Sally, Mother returned home and continued to care for us.

I shudder to think what may have happened to Sally and the large population of handicapped individuals Mother was destined to help if she had not lived.

It seemed as if Mom was put here on earth to accomplish something nobody else could. It didn't come without trials and

tribulation. A great deal of soul searching was part of life for her and Dad. Where could they turn for help? If Mother had not returned home from the hospital, Sally probably would have ended up spending the rest of her life locked up in an institution with periodic visits from family members.

Sally had to be watched closely as a small child, because she would take off for who knows where. Mom finally resorted to tying a rope around her waist and attaching the other end to the large oak tree until she outgrew this habit. She would sit on a large blanket outdoors and play with toys while Mom hung clothes to dry outdoors. She was cute, adorable, and loved by all of us.

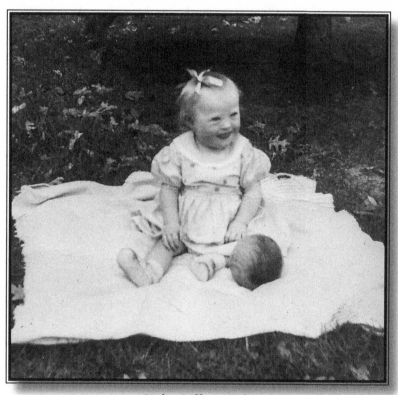

Baby Sally - 1948

My sister, Janet and I were the oldest and helped feed her, change her, care for her daily needs, and babysit when needed.

Mom could never go anywhere unless we were there to help care for Sally. When we went to a family reunion or picnic my siblings often went off and played, but I watched Sally in the playground so my mother was able to enjoy being with other family members. Sometimes I resented it, but knew that Mom needed time to relax.

When we had a family reunion on my mother's side of the family cousins near Sally's age would take her to ride their Shetland Pony with them or let her tag along. We were all one family and cared for one another. The family members were all supportive, kind and protective of her. All of our cousins, aunts, uncles, and siblings considered her an important individual. She was born on our Uncle's birthday and we always celebrated together at one of our homes. We absolutely loved and cherished our little sister.

Things went along as usual until Sally was old enough to be admitted to school for an education. She was seven years old then and eleven years when "The Day Center" was started. Visits to school principals and personnel brought unfavorable results. No educational accommodations were in place for someone with Down Syndrome nor had anyone within the area attempted to enroll such a child. No alternative accommodations or classes were offered. The recommendations were to institutionalize her. Mom struggled with how difficult this would be and many days brought her to tears, which would be running down her cheeks. When I asked her what was wrong she wouldn't say, but one can imagine feeling the same under similar circumstances. There are no guarantees in life, but when an unexpected condition like this happens to a parent, especially in the 1940's, 1950's, 1960's, 1970's,

1980's and earlier, much sorrow and troublesome thoughts come to mind:

1. What can I do to change the situation and provide for my child?
2. Are there other parents in the surrounding communities with children like mine in their homes or were they all behind closed doors somewhere?
3. Did we do something that caused the genetic defect in my child during prenatal years?
4. Are there educational benefits for this child?
5. Can I teach my child at home? What shall I teach her and how?
6. Where do I begin to look for help?
7. What do my neighbors think about us now we have a child who is so different?
8. Will my family, friends, and neighbors give support when I need help?
9. Is there a faith healer or medical doctor somewhere who could help or give guidance?

Many more questions must have surfaced, but these are some that surely must have occurred. A listening ear was found in mothers sisters and siblings, especially an aunt who lived out in the country. They grew close to each other and confided as much as one can. I'm not sure what their conversations consisted of but I am ever grateful for the support she gave to Mother. My job was to take my little cousin for bike rides and play with her while they talked inside.

Much soul searching and prayers continued. There were feelings of frustration and nowhere to turn to for help. Mom didn't know where to turn and started to gain weight caused by stress. Pictures

of her before and after Sally's birth show a remarkable difference in her appearance. No doubt, there was stress. She continued to search for answers and learned of others who had the same plight. Some with their disabled at home were brave enough to go against the tide. Others who succumbed to pressure, tradition and society institutionalized their child, not knowing what else to do. Home schooling was a philosophy that was unheard of, but Sally received instruction in living at home that proved to be very beneficial. She could readily adapt and became one of the better ones that worked out in the community in during her adult life.

We eventually moved to Clare, Michigan, around 1951, fifteen miles closer to Dad's work. This meant no big hills to drive over and an easier commute.

The students in my classroom were very friendly when we moved to Clare and one girl invited me to her home for sleepovers, visits, etc. We spent lunch together walking to town and window shopping. Sometimes another friend came, too. When she came to our house and saw Sally, our friendship ended. The next school day we went window shopping together at lunch time. She whispered behind my back to another friend and generally excluded me. It only took one day to find out we were no longer friends. I think back now and realize she couldn't understand or forgive the differences.

Easter - Sally and Her Brother Larry

Another example was when I was older and married. One couple came to see our newborn baby boy and noticed Sally who came with Mother to help out. Our friends had been to our home every weekend for months, but after seeing Sally, they stopped coming. Shirley kept asking me, "What is wrong with your sister?" I didn't know how to explain, so just said, "There's nothing wrong. She's just fine." They never came to visit again. People were just so uncomfortable and apprehensive of disabled people. They openly stared at them and I felt sorrowful. She was treated like normal in our family and we loved her so much. It was so different than today when we see disabled people out in public all the time. Adaptations are made for physically and mentally handicapped people. Deaf people are seen in public all the time and treated with respect. Those with epilepsy are given medication to overcome the problem. All these physical disabilities used to be considered shameful. They were never seen in public years ago.

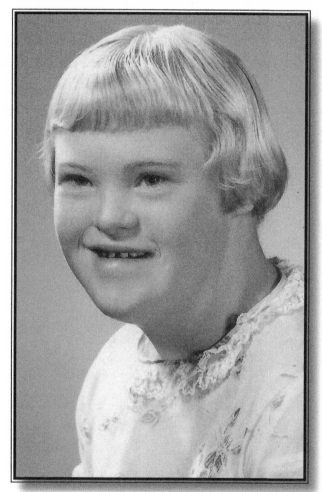

Sally - 8 Years Old

Visits to the new Clare Michigan School System in 1950's for educational opportunities resulted in another dead end. No programs were available, no place to turn, and no hope in the near future. The search went on and eventually led to someone who became a close friend and confident, Irene Otteman, whom I will talk about later.

THE INSTITUTION

In the meantime, Mom and Dad decided there was no alternative except to place her in an institution. I remember when the decision was made to institutionalize her and our long drive to Coldwater, Michigan, the location of The State Institution. I skipped school to go along and cried all the way there and back home. I adored Sally and felt so bad she would be put away. I sat in the car while the three of them went inside. My parents sat in silence all the way there and back, but they must have felt the same way I did. What a dark cloud hung over us. The buildings were clustered together out in the country on a large estate size area. It looked large and terrifying. Studies of old institutions and asylums today prove how dreadful they were. [iv]

THE WAITING PERIOD

Sally had to stay there for a pre-determined waiting period before the family could visit. Mother spent much of the waiting period in tears. It was such a hard decision. When that phase of time ended my mother went to visit. She was appalled at the conditions Sally was living in and immediately withdrew her and brought her home. Officials in the office told her she couldn't do it, that courts had determined Sally was now a ward of the state. Mother said, "She is my child and she will not stay here another day!" Mother had the tenacity and determination to carry out what needed to be done. Sally came home with her and soul searching for answers continued.

Mother tried every means available to find a suitable way to educate Sally. She learned about other children and parents in surrounding communities who were in similar situations. Finally, mother met Irene Otteman who became one of her closest friends. They had a dream for their children to have a better life.

IRENE OTTEMAN

Irene's son, Michael was normal when he was born, but he went into the hospital when only six weeks old to correct the opening from his stomach into the intestine, a constriction or narrowing of a passage, or opening in the body (pyloric stenosis). Their doctor tried to operate and correct the problem, using a local hospital where equipment wasn't adequate. Michael was brain damaged as a result of anesthesia used during the procedure. Irene's family could have sued the hospital, but didn't because they were good friends with the surgeon. She now feels it was part of God's plan. They never could have accomplished what they did without disabled children. She had one daughter and two other sons who are normal. Michael lived only a few years, but Irene still dedicated her life to helping those unfortunate ones like him.

The rest of this story is dedicated to how Margaret McQuiston and Irene Otteman impacted the surrounding communities with their contribution to this special population of people. Information came from newspaper articles, an interview with Irene after Margaret passed away, and interviews with people who were part of their lives.

A PARENT'S ASSOCIATION

Margaret and Irene started a Parent's Association with a group of parents who had developmentally disabled children in 1955. Even then they thought the problem could be handled a better way and the mentally challenged could be integrated into the community. This group of people supported the idea of having some kind of educational opportunity for their children. They made plans to acquire a place to teach.[v]

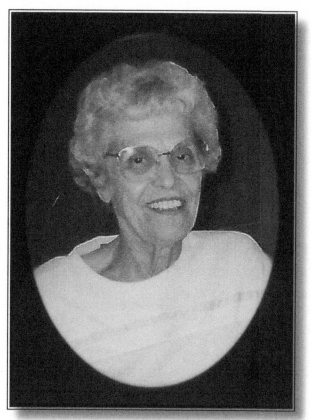

Irene Otteman

FUND RAISING FOR "THE DAY CENTER" - A PLACE TO TEACH

The new school was called "The Day Center," because it taught Daily Living Skills along with education. It was located on the corner of Elm and Henry Streets in Mt. Pleasant, Michigan and opened officially in May 1956. The property was donated by the city, but parents had to provide the structure.

Funds were needed to pay for and move two Quonset Huts from Central Michigan University in Mt. Pleasant, Michigan. The huts were to be attached and infrastructure installed to make them into a school house. Plans had to be presented for township officials approval that met required code. The parent's did whatever was needed to purchase the buildings, which had been used for married housing on campus. They each cost $250 ($2173.11 in 2014) and would be used for classrooms. They were approximately 100' X 20'. One was used as a classroom and kitchen and the other as a recreation area. A utility room, bathrooms, and coatroom connected them. Funds and supplies were needed for the center so Margaret and Irene spearheaded fund raisers, ice cream socials, bake sales, sold candy, and did everything they could think of to

get the needed materials and funds. Members of the newly formed Parent's Association helped support the endeavor.

Fathers and mothers participated in chocolate candy bar sales and made $2,200 which would equate to ($19,123.24 in 2014).

A Bread Company offered them an opportunity to put an advertisement on television. Mothers posed for pictures while eating bread and tea. Forty-five women participated, each one receiving $25.00 ($217.31 in 2014) for a total of $1,125 (or $3,180.54 in 2014) The funds were used to pay for and move the two Quonset Huts from Central Michigan University.[vi]

GETTING THE BUILDINGS READY

Irene's husband was a pipeline worker in the oil wells and Merrill, Margaret's husband, was a steam fitter. They both supported them in getting the buildings ready. Merrill worked hard getting the building ready to pass inspection for occupancy. He worked all day, had a long drive to and from work, and put in extra hours evenings and weekends on the buildings. He conferred with the State Fire Marshall and Isabella County Health Department on adjoining the structures, making sure they passed local codes, etc.

PROVIDING AN EDUCATION

"The Day Center" provided an education that was unavailable in no other way. When a mother needed to go to the doctor, dentist, get groceries, etc. she had to call on family members or make arrangements with one of the neighbors to attend her child. "The Day Center" gave parents until 2:30 each weekday afternoon to do what was needed. It was a real lifesaver for those not working there. However, Margaret and Irene worked there every week day. Margaret lived in Clare and had a group of children she picked up on the way to the center and delivered them home after classes in late afternoon. Irene lived in Mt. Pleasant and had the same scheduled routine with children she transported to and from classes.

They would begin their daily trek early in the morning, picking up children along the way, driving them to "The Day Center," volunteering to teach them educational information, daily living skills, and care for their needs every day. Then they would turn around and take the children home, dropping them along the way. Once they reached home, responsibilities awaited such as laundry, house cleaning, fixing meals, providing for their other children,

shopping, and other home duties. They would no sooner get home, complete a few chores, and it was time to begin the daily trek again. This same routine went on for many years.

It was called "The Day Center," because it wasn't all academics. Students were taught social skills, toilet training, grooming, manners, cooking, crafts, reading, spelling, writing, singing, fun activities, how to set a table and use a napkin, manners, and anything that needed to be done for their benefit. They needed to learn how to socialize, so there was a lot of interaction with others. Dottie's mother, Dorothy S, played the piano for programs and the children's pleasure, occasionally. They had Christmas Programs and celebrated other holidays. All the students loved our mother, Margaret, who devoted her life to helping them have a happier existence than was possible in earlier generations.

There were thirteen children who attended "The Day Center," Steve B, Gary B, Margaret B, John F, Elaine G, Joyce J, Sally McQuiston, Michael M, Michael O, Marcie P, Junior R, Dottie S, and Patrick T.

Parents actively involved were Peg G, Margaret McQuiston, Irene Otteman, Dorothy S, and Ann T. It is amazing how much they accomplished through working together for a common cause.

TUITION

Each student paid $6.00 ($52.15 in 2014) tuition per month which paid for their lunch, transportation, school supplies, and teaching.

TEACHING

They signed a bank note to pay a teacher the first year "The Day Center" was running in May 1956. Lee W was hired as a teacher and mother continued to assist her. Tuition, fund raising, and donations paid Lee's salary. She wasn't certified, but certification was not required until The Phillip's Amendment was passed in 1962. The next year Irene went to The County Board of Commissioners who agreed to fund them $1,500.00 for one year ($12,846.89 in 2014). By then, Irene was immersed in negotiating with school and county officials. Things were progressing slowly, so she invited The County Board of Commissioners to come and observe their classroom. One of the supervisors in the back row asked if she had coffee ready so it wouldn't take more than fifteen minutes. Irene answered, "It's all ready and I've got someone ready and waiting to pour it." They all went to the school at 10:30 a.m. and at noon, Margaret said to Irene, "We've got to get lunch ready to serve these people!" The supervisors couldn't believe what Margaret and Irene had done for this special population! A supervisor from Gilmore Township stood in the door with tears rolling down his cheeks said, "Boy, you people have done a wonderful job here! I would never have believed it possible."[vii]

FUNDING APPROVED

The County Board of Commissioners approved funding for "The Day Center", which lasted until an Amendment passed in 1962 required them to do so.

LIFE AND FAMILY AT HOME

Mother took care of Sally, but there were four other siblings in the family. She was Den Mother for Cub Scouts who were at the house once a week. Our brother Larry, was just three years older than Sally and Mom provided him and his friends with a Cub Scout Den. The boys came to our house every week for an activity down in the basement. She had it planned and the boys had a good time. They came for two or three years until Larry moved out of the scouting program. Margaret was given a certificate for completing Cub Scout Leader Training.

I was in high school by then and had an after school job every day. I would walk from school to a local drug store where I was employed as a clerk and served ice cream and soda. I worked two hours one night and six hours the next. I also worked on Saturdays, Sundays, and holidays. There was work at home to do when I walked in the door after a long day. Laundry that needed folding, ironing, dishes to do, etc. We all had to pitch in and do our part. Sometimes I wonder if I was ever a child. That was just part of life then and we were expected to gain independence and pay for our own clothing and personal needs as soon as we were old enough. Summers gave a break from school for Sally and Mom, but I was working at my full time summer job.

CURRICULUM AT "THE DAY CENTER"

Margaret, my mother, taught cooking classes for the older girls. Having a peer group to participate with was one of the most beneficial parts of the program. Without this interaction they would be socially stymied and unable to function normally.

There were no tried and true ways to teach, so they did the best they possibly could with trial and error as their guide. No reading readiness cards, so they made their own. No proved teaching methods were available for a disabled person. Sally was in Irene's reading program and they tried to teach her the word "can" with a picture of dog food. Every day they would go through the reading drills and Sally would say, "dog food." One day Irene just yelled she was so excited when Sally said "can." They would just try and try until one day the light came on and they learned it.

One day Margaret was giving a student spelling words. She said, "Oh I have a mental block." Her little friend said, "Listen, if you had one you would be in worse shape than you are now." Irene and Margaret just cracked up laughing. When you stop to remember the good times, there were many happy memories.

EDUCATING THE DISABLED

Teaching methods and fundamental tools are so readily available today. It seems like a world of difference when compared to the methods used in "The Day Center." These two mother's did the best they could to teach students under difficult circumstances. They purchased their own teaching materials, had no training other than caring for the children, and a willing heart and mind. Basic math skills, reading, writing, making change with money, etc. were taught along with Daily Living Skills. Today, education has come so much further with many methods and support for parents and teachers. Handicapped students are given adaptations and classroom teachers who have been trained to teach them. Those with challenges have so much more support, compassion and understanding now. Even though things were difficult, the road was paved for their progress back in these early years when "The Day Center" and The Parent's Association was formed.

I would volunteer to help teach the students whenever a school day was cancelled due to holidays. I learned how very much they are just like other people. I didn't feel they were so different and enjoyed the experience of teaching. It helped me develop

compassion for others that could not be gained in any other way. They are just like us and have the same needs. Today, there are many proven methods in educating those who are disabled. How far we have come thanks to people like my mother and Irene.

SCHOOL LUNCHES

The Department of Social Services approved "The Day Center" to receive surplus commodities for lunches. There was plenty of cheese, but the students got so tired of eating it. Part of the curriculum for students was to learn how to be self-sufficient, so sometimes they were involved in learning how to prepare food. Margaret prepared grilled cheese sandwiches, macaroni and cheese, cheese soufflé, welsh rarebit and every kind of recipe she could think of for variety, but it was of no use. One day they had an idea about trading with other recipients for peanut butter. They took the bulk cheese to the Department of Social Services parking lot, placed it on the hood of their car, covered it with cheese cloth, and asked clients receiving commodities if they would trade cheese for peanut butter. Many were willing to make the trade and the students never tired of peanut butter. A Social Service Employee came out into the parking lot and said, "We don't know if it's legal to do this!" They looked at each other and said, "Do you know if it's legal?" They both agreed they didn't know, so they said, "Well, we're not going to worry about it then," and they continued trading cheese for peanut butter until they had a good supply for

the student's lunches. They always received more cheese than could be used and fourteen pounds of butter was too much. They went to the Social Services parking lot again and asked people to exchange peanut butter for butter. Again, many were willing to make the trade. It got so people would see them in the parking lot and know what they wanted. The trading went on for several years.

Margaret would make peanut butter and black strap molasses cookies for the students. They all loved them and had fun learning how to help prepare them. They never seemed to tire of peanut butter.

They didn't have any meat to make soup, chili or casseroles, so Margaret and Irene contacted a conservation officer to see if he could get them a deer. They invited him to "The Day Center" to see what they were doing and how it would be used. He watched the classes and saw a freezer so he knew they had a place to store meat. He said there would be no charge for the meat, except for processing it. They explained that they were willing to pay for processing the meat. He called one night about 8:00 p.m. to say a deer had been hit by a truck and killed. He said, "Where should I take it?" Irene answered, "You mean you will take it?" and he said, "Yes." He took it to the closest meat locker plant where it was ground up with pork and used in place of hamburger. It tasted so good you couldn't tell it was venison. Margaret and Irene alternated paying for the meat processing out of their own pockets. They were truly guardian angels for this special population of people.

Deer were plentiful in Michigan and often accidentally killed as they crossed roads. It seemed that headlights blinded them and they didn't watch out for driving vehicles, even though drivers tried to avoid them. Deer crossing signs were posted and vehicles were constantly on the lookout to avoid hitting deer.

Rather than let fresh deer meat go to waste, it was used in school and college cafeterias as a substitute for ground beef, added to soup dishes, chili, Sloppy Joe's, etc. The meat was processed immediately and not left by the wayside to rot. Conservation officers knew how to handle such cases.

AMENDMENT PASSED IN 1962

Until an Amendment was passed in 1962 requiring schools to admit disabled children, parent's had to provide for a disabled child's education. There was no participation from the government to assist them financially or any other way. When the amendment passed in 1962, county school departments agreed to pay 75% of their budget if the local government would pay 25%. They qualified for this, so Irene went to the school board, which immediately made plans to get funding.

"The Day Center" was the very first establishment for The Intermediate School District, which became Gratiot-Isabella Intermediate School District. The Gratiot County Public School District came out of these small but influential beginnings. Many thanks go to those unsung heroes who paved the way for programs to be established.[viii]

FUNDING APPROVED

After the budget funding was approved, they agreed to let teachers be grandfathered in, allowing them two years to prepare for certification. The teacher and aide would spend six hours a day with developmentally disabled children. They provided transportation in addition to teaching. After spending all day with children, they were emotionally and physically spent and didn't have the energy for college classes. The idea of taking a full college load to certify in addition to teaching all day just wasn't practical. Irene went to meeting after meeting while Margaret talked with The Parent's Association about it.

When Irene left to do community interaction and make proposals for "The Day Center," Margaret had all the teaching, lunches, bathroom help, etc., but Irene was the mouthpiece with the community and Margaret supported her. When the public school system was going to take over "The Day Center" they had mixed feelings. They were excited it would be a public school, but felt sadness it was ending. They both began to cry.[ix]

Margaret moved on to other endeavors, because Sally was not eligible to be a student anymore. When Sally turned 26 in 1974 she no longer qualified for "The Day Center" program.

THE STATE CAPITAL IN LANSING, MICHIGAN

Irene went to The State Capital in Lansing, Michigan to speak to the legislature. She spent two days listening to them debate the issue before they allowed her to speak from the podium. She said, "As I sit here and listen to you fellows, I don't think you have the vaguest idea of what it is all about. You are making plans to give us things on one hand, and on the other hand you are taking it all away." She explained how difficult it would be to certify the teachers within two years and that it wasn't really necessary. All the students really needed was tender loving care and they are happy as could be. She suggested they come to visit "The Day Center" and observe what they were doing. She started to walk away when a man in the back row said, "You better listen to that woman! She knows what she's talking about!" They finally agreed to give them more time.[x]

A SCHOOL BUS

Margaret and Irene talked about how wonderful it would be to have a school bus for the children. They were able to save about $4,000 ($34,258.38 in 2014) from the $1,500 ($12,846.89 in 2014) and limited funds that had been given to them each year. They wanted to see if something could be done to support this idea. They talked to the school board and Irene went to the Ford automobile sales owner in Mt. Pleasant, Michigan to discuss buying a mini-bus with the funds. He called her up and said, "Irene, if you can get the supervisors to agree to donate the $4,000 ($34,258.38 in 2014) we will put in the rest of the money to purchase a bus. The money didn't belong to "The Day Center" anymore; it belonged to The Board of Supervisor's. "The Day Center" teachers saved the funds with intentions of using it for the school. Margaret and Irene continued to haul the students back and forth in their cars in addition to teaching all day. She asked them if they could keep the $4,000 ($34,258.38 in 2014) and the owner of Ford company would donate the rest. A board member said, "Well, that's the first time anybody ever came back and called it our money. Once we give it to people, it's their money." They

stood up, applauded her, and approved the school bus. Margaret and Irene danced around like little children when they knew the school bus was approved. This was a major step in progress from meager beginnings to recognition as a public school.

SPECIAL OLYMPICS

The Special Olympics program became a large part of their activities in 1973 when it was established at Central Michigan University. They participated in 24 regional events and 150 local ones that would take place on campus. News article, "Special Olympics Program Underway."[xi] states: The first Special Olympics held in Michigan on Central Michigan University Campus would be held in May and June, 1973. This would be the fifth annual Michigan event, the previous four having been in Kalamazoo and Adrian.

They were honored with a visit from Eunice Kennedy Schriver in 1975 when International Games were held on campus of CMU. The Joseph P. Kennedy Foundation, The Michigan Department of Education, and Central Michigan University were co-sponsors. More than 1,000 youngsters were expected to participate in the events at a "State Special Olympics at CMU on Friday and Saturday. A variety of competition included swimming, gymnastics, bowling, handball and softball, track and field, and wheelchair bowling.. It included an opening and closing ceremony, clinics, dinner, parade, and dancing and movies in the evening." [xii]

It has since become a large part of the activities students and staff at Central Michigan University enjoy. A large Special Olympics building sits on campus today. It was given to Special Olympics by the university for a small fee. They were told the building was theirs to use however it seemed fit and any improvements were on them. The program is highly active with events going on presently.

The Special Olympics building is well maintained and functional with a large staff and volunteers. Individual and team sports such as skiing, basketball, cycling, gymnastics, aquatics, figure skating, horseshoes, snowboarding, bowling, golf, soccer, softball, volleyball, etc. are sponsored by Special Olympics. Benefits of school based programs for students and teachers include social interaction, school spirit, physical fitness, sports skills, self-esteem and competitiveness, and recognition by peers. They have resource materials available for all Special Olympic Michigan programs

The mission statement for Special Olympics is to provide year round sports training and athletic competition in a variety of Olympic type sports for children and adults with intellectual disabilities. The goal is to give them continual opportunities to develop physical fitness, develop courage, experience joy, and participate in the sharing of gifts, skills and friendships with families, and other Special Olympic candidates in the communities.

Sally earned three gold medals for participation in Special Olympics.

Irene ordered T-Shirts for the participants with the Devine House logo. When they came in the name was spelled Divine House rather than Devine House. Irene contacted the company who said, "Well, maybe it should say DIVINE HOUSE, considering the historic event." Those people who have the original T-Shirts with incorrect spelling have a historical keepsake.[xiii]

News article states: <u>Special Olympics Program Underway</u> - More than 6,000 boys and girls from all parts of Michigan were

expected to participate in the 1973 Michigan Special Olympics organized for handicapped children.

Dr. M. LeRoy Reynolds, chairman of the Department of Special Education at Central Michigan University, was state director of the event. He noted that: "as a child improves his performance in the gymnasium and on the playing field, he also improves in his classroom, at home, and eventually on the job." Recent scientific research had shown that physical activities, sports and competitive athletics are a major means of reaching the mentally challenged."[xiv]

Co-sponsors of the 1973 program were, The Joseph P. Kennedy Jr. Foundation, The Michigan Department of Education and Central Michigan University.

The Joseph P. Kennedy Jr. Foundation conceived the annual event in 1968 to provide not only fun and exercise of the retarded, but also to enhance the proven physical and psychological benefits in the long process of rehabilitation. This was the fifth annual Michigan event, the previous four having been in Kalamazoo and Adrian."[xv]

News article: State Special Olympics at CMU Friday, Saturday said: More than 1,000 youngsters are expected to participate in Michigan Special Olympics hosted Friday and Saturday at CMU.[xvi]

Dr. Tim Otteman said, "One thing I will tell you is that Michigan Special Olympics has its home right here in Mt. Pleasant."[xvii] Tim doesn't know if that would have happened if Irene and parents like Margaret had not started the process. It really is the hub of appropriately dealing with diversity of all people who have a mental disability. Michigan Special Olympics is probably one of the top five Special Olympic programs in the country in terms of the number of volunteers involved, but also athletes that are being trained and have competition. He thinks they are all part of how this community has embraced dealing with that population. They are accepted so well in the community

that CMU students can't wait to sign up and volunteer for Special Olympics. The support is unbelievable. It's one of those experiences that, as a college student here on campus, if you don't get involved with Special Olympics on campus or winter games in Traverse City, you are missing out on what it is like to be a Chippewa. They really do embrace the fact that Mt. Pleasant is the home of Central Michigan University, but also the home of Michigan Special Olympics now. It's very much embraced. Here's an example of the cooperative effort, the Special Olympic building used to be the Road Commission Building for the city of Mt. Pleasant and Isabella County.CMU made it available to Special Olympics for a small fee and told them to renovate it, but those costs are on the Special Olympic people. Employees of Special Olympics are a big part of CMU and the cooperative effort is just unbelievable. It is remarkable what has happened and how well they are accepted. Many more mentally challenged are being kept at home now, being in a loving home. It is now typical of families to embrace their children, and they are so much better off being raised in their homes with family. It is so much more common place. [xviii]

Today the students on Central Michigan University Campus make Special Olympics part of their experience. It is just part of being a Chippewa and wouldn't be complete without their participation as volunteers.

THE MT. PLEASANT STATE HOME AND TRAINING SCHOOL REGIONAL CENTER

The original Regional Center was a home for Native American Indians and was known as the Indian Industrial School from 1893 to 1933. In 1934 the grounds were converted from a boarding school for Native American children to a 'farm colony' for the Lapeer State Home and Training School. When the facility reopened in 1934 as the Michigan Home and Training School, the care of the developmentally disabled was much different than today's standards. The residents were men from the state home in Lapeer who provided labor to operate the farm and dairy operations at the facility, and were available for hire by community members for day jobs. At this time, the only hospital located in Mt. Pleasant existed at the 'Michigan Home,' the terms used by locals at the time for the Mt. Pleasant Regional Center.

In 1946, the institution was renamed <u>Mt. Pleasant State Home and Training School</u>. It became known as <u>The Center for Human Development</u>, a center for developmentally disabled. Research

at the Clarke Historical Library indicates that the time between the opening of the facility in 1934 until the reforms in Special Education laws and practices in the 1960s and 1970s made for a dark time at the facility. Care was confined to only food and shelter. Efficiency was emphasized over anything else during this time, and living conditions did not meet the space and privacy requirements of today. Residents were handled in groups of up to 50, and photos show dormitories filled with wall-to-wall beds in day rooms that slept 50 to a room. A building spree happened in the 1950s, with buildings designed to provide a custodial level of care in the most expedient manner. Many of the buildings still in existence on the grounds today were constructed during this time.

Liberal admissions policies during the early decades required only the signatures of two doctors saying that a person was 'retarded.' Due to this, many residents were 'quite capable people' according to an In-Service Training Department video.

There were approximately 140 residents there in 1998 when Sally became a resident.

Today the Regional Center does not exist. The buildings have been demolished except for a couple that are designated as historical and a large grassy area is all that is left. The people who once lived there have been integrated within communities. As one would imagine, many sad things happened in the past on those grounds, but progress happened as well. At one time the Mt. Pleasant Center was the fourth biggest provider of jobs in Mt. Pleasant. Currently, it is a small abandoned city sitting at the north edge of this town, waiting for the next chapter.[xix]

POT LUCK DINNERS
AND PICNICS

The Regional Center needed someone to help parents get to know each other and give support. Parents would come on Parent's Day when they could have lunch with their children. It was just a project they could do for others that got started with a discussion between the Irene and Margaret. Margaret said, "What do you think about having a pot luck dinner on Parent's Day?" The people from the association would bring dishes of food to serve to parents who visited The State Home and Training Center. Some of the parents came as far away as Mt. Morris and Traverse City to visit their family's children at The State Home on Parent's Day. There was nothing to do with them except take them to lunch at a restaurant. Irene was not directly affiliated with that parent's organization as the group was different than "The Day Center" students. However, they were interested in helping parents in similar situations in Central Michigan, Clare and Isabella Counties.

Margaret and Irene decided to help the parents out by starting potluck dinners for them, which was a great success. They had a wonderful time. The funds went to benefit the developmentally

disabled. For example, if they needed record players or roller skates, trips to circus or ice follies, sewing machines, toboggans or sleds, Boy Scout uniforms, recreational equipment, etc. the institution didn't have money for, The Parent's Association would provide it. The Parent's Association also provided residents with paint and tools for recreation use, materials for religious classes and most importantly "Little Toot," the train used on the grounds and The Sheltered Workshop. The tractor was donated by the bowling proprietor so the residents would come out and bowl. They were successful in having a group who liked to bowl. An annual formal dance was held yearly and instituted by The Parent's Association. The Parent's Association improved the grounds, especially playgrounds. Play equipment and picnic tables were installed for families to use when visiting their children. They donated $100 a year to The Gaylord State Home and contributed the same amount yearly to research (equates to $869.58 in 2014).

Hazel S watched over the patients at Christmas and everyone in the facility received a Christmas gift. Margaret was a large part of this and helped with the project of gift giving.

When you get to know these people and work with them there is so much that can be done. The annual picnic was held for over forty-five years and all the residents and community could take part. They had a live band, hot dogs, hamburgers, food, and vendors who participated. Margaret and Merrill's grandchildren sometimes went to the activity and have many memories.

Margaret made 123 teddy bears and sold them to raise funds for the hospital unit. Some of the other mothers made bears, but no one like Margaret did.[xx]

4-H PROGRAM AT THE REGIONAL CENTER

Sally achieved 4-H certificates through the Regional Center. Certificates were for crafts, cooking, sewing, personal improvements, and flower gardening. Sally did a lot of crafts, had a lot of 4-H ribbons, and certificates. She did such beautiful hand embroidered pillow cases, rugs and yardstick holders that parents bought them from her. She also made rugs and embroidered yardstick holders the public purchased.[xxi]

Edith P was the 4-H Club leader then. Margaret worked with the 4-H group, also.

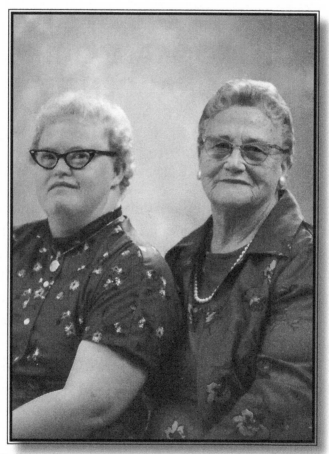

Sally and her mother, Margaret (Dunkle) McQuiston

HOME FOR TRAINABLE RETARDED

When the state started scaling down the facilities under operation. The Department of Mental Health was committed to placing residents of the state facilities in least restrictive environment, and under contract with the state housing authority a certain percentage of residents must come from a state institution; however, many of the people would be from homes where they have been all of their lives and whose parents felt a burden for their care. This would give the parents assurance their children were cared for under supervision in a happy home atmosphere where they could interact with their peers. Irene and Peg Gillis explained.[xxii]

ICE CREAM SOCIAL

When they needed cakes for an ice cream social, Irene and Margaret spearheaded it. Irene recalls when they didn't know if anyone else would contribute, she would call Margaret to say, "I don't think we will have enough cakes." Margaret said, "How many do we need?" Irene said "Well, we would each have to make a dozen or so." Margaret said, "Well, we better get started." They each made a dozen cakes and put them in the freezer until the social. Irene had a station wagon and four little kids. They had a good friend, Jim B who lived in Mt. Pleasant. He did all the repair work on radios and record players for The Mt. Pleasant State Home and Training School (The Regional Center). Jim owned a loud speaker that he loaned to her. She drove all around town telling everyone about The Ice Cream Social that was held at the Catholic Church. They had a great turnout and made $400 ($3,425.84 in 2014).

The Parent's Association got involved and provided toys and games for kids and parents to have interaction when they visited. There were 296 persons involved with The Mt. Pleasant State Home and Training School and many of those were dues paying members, but only about 30 were active in the association.

Members came from 34 counties in the state with representatives from Detroit, Port Huron, Muskegon, Grand Rapids, Traverse City, Clare and Mt. Pleasant, Michigan.

Monthly meetings were held at the Mt. Pleasant facility. This gave parents an opportunity to meet with their children as well as other parents with similar problems.

Anyone was invited to join, even people without family members were involved. Margaret McQuiston said that the group was dedicated to help disabled children all over the state and nation.

The activities they provided were many. Margaret's grandchildren remember standing on the corner selling raffle tickets for the picnic. Several Clare residents purchased them. The picnic was a big affair with vendors, interested people from all walks of life, prizes given, fund raising, etc. The grandchildren said Margaret would sit at the calculator for hours tallying up expenditures, income, etc. to balance the books for this large event. Her calculator was the old fashioned kind with paper strips that were spread all over the table where she worked on accounting for the affair.

Margaret donated hundreds of hours for her work as treasurer of the group. Margaret was presented Citations for her volunteer services. She volunteered 250 hours in 1964, 500 hours in 1965, 600 hours in 1966 according to certificates presented to her by The Mt. Pleasant State Home and Training School.

The Mt. Pleasant Association for Retarded Children, (the name it was called) provided for patient welfare. Margaret was a big part of the group. The constitution listed objectives, but parent involvement accomplished much more. The Parent's Association was formed to help provide increased education, recreation, entertainment, comfort, medical treatment and hospital facilities to residents at The Mt. Pleasant State Home and Training

School. Margaret received honorary certificates from The Parent's Association in 1982.

"When you get involved in the association you see your problems in a different perspective," Mrs. Margaret McQuiston, treasurer of the organization from Clare said.

Mrs. Barbara Pullen, president of the group from St. Louis said, "You forget your own self-pity when you get involved in the lives of so many others. Their problems seem so much worse than your own."

MEMORIES OF IRENE FROM GRANDSON TIM OTTEMAN, PHD

Irene was honored as Mt. Pleasant citizen of year in 1965. Tim is a professor at Central Michigan University. Tim thinks about what his vocation and relates it to his grandmother, Irene who was a phenomenal advocate for people with disabilities. She had to deal with community mental health, and community leaders to get Devine house built, deal with the banks to get financing, etc. That part is a side never seen as a grandma, but now as a person who talks to students and prepares them for careers in recreation, he realizes just how much goes on behind the scenes. She was a very capable person to have the ability to do it and got the backing of John Devine, Attorney very early. There was some support within the community, but she was definitely the driving force. His grandfather was a very bright man, an engineer and had worked at Dow Chemical and made his living in the oil business. Tim remembers Irene telling stories of mistreatment of clients at the Regional Center when she worked there and how there had to be a better way to have a better quality of life. Through the process

of "The Day Center" Quonset Huts into the Devine House, she was an amazing woman.

There are a couple of buildings left at the regional center that were part of the original Native American schools and some of the land has been protected, but the rest is all gone. Streets are gone, the land is mowed and maintained by the state, and old buildings are gone. Nobody really knows what future plans are, but it has disappeared from the landscape. There was a big fear that residents were all criminals, when in reality many were quite capable and were placed early on. Some probably weren't capable but his grandma had to wade her way through these and say, "There are separate generations and capabilities of them in terms of what their skills are." Some need to be at home and not in the community, but some are more capable and need to be out and about and it will help them in their quality of life.

Tim Otteman, Irene's grandson, runs into some disabled today that do a variety of things and are hourly workers whether doing custodial housekeeping things at local hotels, lots of work crews cleaning parking lots, crews cleaning tables in restaurants, bus service, custodial work, in a variety of capacities. It's amazing when he sees them how they give each other a hug. One is named David and is the biggest Green Bay Packer fan on the planet. Every time Tim sees him they exchanges jokes about how he is going to have him switch into a Lion's fan and he says, "Oh no you're not, so it's been a joke for 35 years." David has fun as a fan. Working is something he does that is not demeaning and is a prideful thing when he's out in the community. Working gives them an opportunity to get up, get dressed, go somewhere to work, be on time, put in a good days work, and all those things are appreciative when you do them successfully. If you don't have that thing to do it becomes easy to slack off so he thinks there are so many positive aspects to having them in that capacity or in a group home setting.

The next step into the community is the employment piece. It is just a very neat program.

Tim's degree is in Journalism with an Advertising and Public Relations minor, Master's in Sports Administration, and Doctoral Degree in Educational Leadership. For his Master's Degree, he had an internship in Los Angeles, California with California Special Olympics. The next eleven years of his life he went from California to Detroit to Denver back to Mt. Pleasant, all running events in Special Olympics programs. His work history before becoming a college professor in CMU was totally driven in the concept of sports and recreation, which is now what he teaches, but it was for the special population. It was great to grow up learning about events and having the ability to be around all of the people who have developmental disabilities from stereotype Down Syndrome athlete to the very high end athlete who might just have an IQ number just slightly below the national standard to Prader Willi Syndrome, to all athlete's out there. A very integral large part of his life was seeing just how diverse the world is. Part of it was leaving Mt. Pleasant and going to Los Angeles, but the other part of it is dealing with people that have developmental disabilities. He realizes how we do have differences, but we are so similar in reality and so much alike. Irene once said, "Just forget about the differences and realize how very much we are alike and we are all just people." There was so much love given and Irene was the expert.

Tim would joke with Irene all the time that she had her children, the grandchildren, and all the disabled. She really felt that way. These were all her children and when they all said, "Well, Irene is going to bring one of her kids with her," that didn't mean them, it usually meant she was bringing someone from one of the houses with her. One thing she told them was the concept of Pennies from Heaven. Grandma really instilled in all of them that

'you do good things for people because it's the right thing to do' not because you have to do it. She said it from the concept that when you do good things for people here, there will be big piles of pennies in heaven for you. The running joke for them was, "There had to be a whole bunch of pennies up there somewhere, when she passed away." What a sweet concept and unique idea.

They took the idea and did a Memorial Golf Tournament when his little sister passed away. The tournament was done for fifteen years to raise money for nurse education. The last event they did was a game called "Pennies from Heaven." They asked everyone to bring fifteen rolls of pennies to the tournament, because it was their fifteenth year so that is $7.50 ($61.54 in 2014) worth of pennies, when in theory they were going to make another fifteen hundred dollars. The community grabbed a hold of the idea and they made over $6,000 ($49,235.70 in 2014) just collecting pennies. Irene's concept has carried through to lots of things. Her devotion to disabled helped mold Tim's life and his understanding of people who are different in some way.

It's wonderful to think how far this concept has come where you see those people out in public now where before they were just locked up somewhere put into an institution and not even kept at home.

SALLY NEEDED SOCIALIZATION

When Sally grew older she needed more socialization with others so Margaret and Merrill decided to let her live at the Mt. Pleasant State Home and Training School in Mt. Pleasant, Michigan in 1962. She went there to live, but Margaret continued to be involved with her almost daily.

It was a hard decision to make, but they wanted what was best for Sally. She was so lonely at home living with them and nobody interested in being her friend. She grew to have pretend friends and associations with others and it was evident there was a void that needed to be filled. It was a big decision to make, but it proved to be a the right thing.

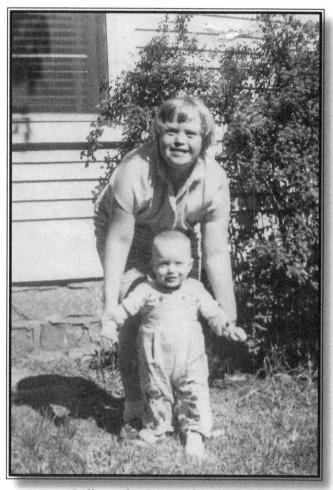

Sally with Her Nephew - 1959

Sally lived in The Mt. Pleasant State Home and Training School until Foster Program's came into effect. Margaret lived close enough to be involved with the facility and was there almost daily. Sally was happy and given the responsibility of washing hair in the Beauty Shop and gave manicures to the residents. She felt proud of her job. It gave her a sense of pride. Her own appearance was always neat, clean, and presentable and her hands were always manicured.

Giving parental support helped Margaret know about Sally's welfare. She visited her almost every day and became a welcome sight to others. Residents would give her a great big hug when she entered the door. She became that parent they seldom saw.

Sally adjusted well to her surroundings in The State Home and Training School and when the doors were about to close, Margaret was a very concerned parent. She didn't think they would ever be accepted by the general public and feared Sally and others like her would be discriminated against.

She expressed her concerns in a full page Clare Sentinel article. Part of the article is quoted next.

Letters to the editor:

Dear Editor:

I am the parent of a retarded child and live in the Clare School District, although I am in Isabella county and pay taxes in both counties.

I have stood by and heard the ridicule made of the State Home and Training School at Mt. Pleasant, but when I ask if they have visited the home, nine out of ten said they hadn't but remarked they had a good friend or relative that had first hand information.

I put my child in the Mt. Pleasant State Home and Training School ten years ago and I can honestly say she

has learned more and was given a better outlook on life than the public has ever offered.

I have heard about the parents putting them in the Mt. Pleasant State Home and Training School and forgetting them, but I have been treasurer of the Mt. Pleasant Association for Retarded Children for six years and donated a lot of time for our children at the home and the letters I receive from parents tell me many of them wake up in the night and wonder if putting them in the Home was the solution, but they were advised by the doctors this was the best thing and they wouldn't have to worry over them when they got old and could no longer provide a home for them.

I heard a good Christian say she was a substitute teacher at the Clare Special Ed School and one day wanted to work at the church, as she was chairman of a centennial dinner and had to come over to the church late because she had to baby sit with a bunch of idiots that couldn't be taught anything and had snotty noses and slurred speeches, so you couldn't understand what they were saying. When I came out of the church that day I thanked God my child was in the Mt. Pleasant State Home and Training School where Sally washed hair for others, did their nails and learned to tolerate the ones more handicapped than she is.

Our dear Governor must be real proud of his Mental Health Department for trying to abolish all the good we parents and the staff have accomplished at the Mt. Pleasant State Home and Training School. Our senators and House of Representatives should be real happy over their accomplishments in making a law that every child should be put out in the community and given an equal chance. These poor unfortunate children can't speak or protect their rights, because their speech is too slurred, but pray tell me, "Have you better to offer?" My child bowls, plays bingo, goes to movies provided on the grounds

by the parents organization and the parents. We have purchased drapes, bedspreads, washers and dryers, radios, phonographs, provided music and refreshments and this may surprise you to know, we do pay to the best of our ability and if the child doesn't have money, parents and friends see that they have it so every child has an equal opportunity and the State of Michigan doesn't provide these things. The money they do spend on our children is small compared to their trips to foreign countries and all over the world.

My child will come home to stay and we will provide for her, but she will leave opportunities and friendship, her job at the beauty shop and spend her time in front of a TV and embroidery, with no friends and no recreation. We are too old and she can't cope with the high IQ's of the outside world.

Yes, these children are handicapped, but they are more than handicapped. They were born this way and we don't know why, but God provided a home for them. Now I see in the papers big headlines reading, "WANTED, HOMES FOR THE HANDICAPPED" Do these people know it is a 24 hour day care and a lifetime job? Needless to say, the rewards one gains from such an accomplishment are great. God only knows how true this is. Who should know better than a parent?

These parents have children in their later years of life and our organization is too small to fight city hall. We do thank the public for all the help they have given us in the past and hope in some small way they will help us hold the State Home and Training School together and keep our dear ones as happy as they can. I am sure the rewards will be much more than putting these children out in the world with no future.

Dr. Diamond probably made mistakes, don't we all? But the one thing I liked about him, he fought for the

health and happiness of our children and if these people had fought to hold the State Home and Training School together and provide a neat place for them to live and be loved and happy in their own way, they would also be rewarded in heaven. I say, "Thank God my child has had the privilege of being a resident at the State Home and Training School." I wish someone would tell me where these children will receive the training, companionship and well being she has had at the home.

Maybe it isn't the best, but it is better than putting these children out into the world to be pushed around and don't say I am a parent that wants something for nothing from the state. I paid for my child to stay at the home and I was glad to do it and if I wanted to get rid of her and never think of her again, I would commit suicide, but I never did take the easy way out, so I will stand by and see my child hurt and pay taxes to support our special education program and help pay the raises for the heads of our government and pray to God that someday there will be something better.

Mrs. Merrill McQuiston, Rt. 2, Clare[xxiii]

You can see that Margaret, (Mom), had reservations about the children being accepted by the general public. She was rightfully worried and concerned about the turn society was making for disabled adults and children. Familiarity of past responses and indifference towards the disabled were fresh in her mind and left a bad impression. Sally was one of the first ones to experience being out into the community, and society had a lot of attitude changes to make. Thankfully, we have come a long way.

When the children were fostered out in the community, my parents chose to bring Sally home to live with them once more.

THE WORKSHOP

Sally lived in Clare, but always came to Mt. Pleasant. Sally got too old to qualify for public schools, so they started The Workshop in the basement of Isabella County Jail in the 1950's where Don Gillis was sheriff and let them use the space.[xxiv] The mentally challenged were not eligible for public school after they turned twenty-six and the workshop was for their benefit. Margaret did volunteer work there, too. The same Parent's Association members were involved and it was an extension of the earlier program provided for them at a younger age. This was the early beginnings of Mid-Michigan Industries, which is a strong industry for the disabled still in existence today. Don Gillis was sheriff and Peg and Don Gillis were involved with the disabled in starting a workshop located in the huge unused space in the basement of the sheriff's department.[xxv] Irene, Margaret and other parent's were supporters of this endeavor. Margaret and Irene were both on the board of directors. The workshop started in the 1970's and they did skilled work. [xxvi]

MID-MICHIGAN INDUSTRIES

Mid-Michigan Industry (MMI) was founded in 1973 and the founding board members were: George Rouman, Lee Wirth, Bill Shirley, Ann Thering, Beverly Gross, Roger Coles, Fred Steffke, Peter Mongeau, and Gloria Downhour.

There was another building outside of Clare with Mid-Michigan Industries for older higher functioning groups. Margaret, Merrill, and Irene worked real hard on that project, because they had the experience and knew how to do it. It wasn't for their students, but it didn't matter. My father Merrill McQuiston, my brother Larry, grandchildren of McQuiston's, a friend Duane P, and other parents helped. Merrill did the heating and pipe work in the building as a volunteer. My mother, Margaret McQuiston, received recognition and commendation from Mid-Michigan Industries for her part in getting the project going. She was presented with an Certificate of Award for outstanding achievement in five years of board participation from Mid-Michigan Industries on December 7, 1981[xxvii].

Alan Schilling, President, started working at MMI in 1980 and knew both Margaret and Sally and had good memories and

great respect for both of them. They both played important roles in getting MMI to who they are today.[xxviii]

This was during a time of transition from MMI being basically a small social recreation program to a work activity program in which work became a focus and earning a paycheck a goal of those attending. They celebrated the fortieth anniversary year in existence in 2013. The industry started out as a small program to $6,000,000 budget now.

"Back in 1973, a group of parents and professionals with a mutual dream came together and established the Isabella County Adult Activity Center. Their dream was to provide opportunities to individuals with developmental disabilities and engage them in structured activities with their peers that led to a more meaningful life. Progress was made.

In 1977, the Board of Directors for the Center also had a dream, "To improve the quality of life for individuals by providing opportunities for them to work and earn a paycheck." After years of MMI providing activities to the individuals attending, our participants decided that they too had a dream that they wanted something more to do and that included having the ability to work and earn money of their own. Again, progress was made.

In the seventies, the state had a dream of eliminating institutions for the developmentally disabled. The Mid Michigan Work Activity Center[xxix] became part of that dream to assist in moving people from the Mt. Pleasant Center to their home communities.

In the early 80's, the emphasis was on production and once again the board had a dream of expanding the production capabilities in manufacturing and a new building was procured as well as a rebranding to Mid-Michigan Industries, Inc. (MMI). Later in the 80's, the state dreamed that people with disabilities could and should be able to work in community jobs and

Supported Employment was born. MMI soon became one of the largest providers of Support Employment in the state and progress continued.

In the 90's, the state had a dream that individuals deserved the right to decide for themselves what they would like to do, rather than being told what they needed to do. Thus, the era of self determination and person centered planning began.

The new millennium brought with it dreams of greater independence for all and opportunities to create a meaningful life as they defined it. The dream of deinstitutionalization became reality and person centered planning became the standard. MMI was able to create options and choices based on the interest of those receiving services and community access was made available to everyone. The opportunity to work both in the community and in MMI's manufacturing operations increased.

In June of 2013, MMI will celebrate forty years of pursuing our dreams and will have had the privilege of serving our community, our partners, and most all those who have benefited from our services over the years. As we move forward together, we must continue to dream to create a brighter future for all people regardless of their own individual challenges.

A brighter future is ours to have if we continue to "Dare to Dream." Alan Schilling, President

HIGHLIGHTS FROM 2012 for MMI

- MMI served almost 1,500 people during the past year.
- We expanded our Community Living Supports program into four counties.
- Manufacturing exceeded our budgeted amount for the first time since 2008.
- The MMI art studios in Clare and Mt. Pleasant are well underway with many pieces of art being sold to the public.
- MMI had two teams of cyclists in this year's "Le Tour De Mont Pleasant."
- Community Employment acquired over 20 new community contracts.
- We began providing 24 hour CLS services to a participant
- MMI's JET program, funded by a grant through CAMWC, was top in the state for work participation for fiscal year 2011-2012.

Sally worked at MMI and was proud of the contribution she made. It gave her an opportunity to interact with peers, build

self-reliance and independence, provide for a small paycheck, and contribute to society in her own way.

Alan's biggest memories of Margaret were her volunteering with other parents by providing holiday activities for all who attended MMI. The largest activity was the annual holiday dinner that fell between Thanksgiving and Christmas in which they served a turkey dinner to approximately 200 people. In addition, this parent group provided a range of activities and entertainment around all the holidays to enrich the lives of those receiving services.

MMI has locations in Clare County, Gratiot County, Isabella County, and Southern Operations in Stanton, Michigan today.

This all began with a group of parents who had a dream for a better life for their children early on. It shows that from humble beginnings MMI has evolved into an organization dedicated to their mission of "Enriching lives through employment, training, and community access."[xxx]

PUBLIC LAW 94-142 PROVIDED FREE PUBLIC EDUCATION FOR CHILDREN WITH DISABILITIES

When it was passed in 1975, P.L. 94-142 guaranteed a free appropriate public education to each child with a disability. This law had a dramatic, positive impact on millions of children with disabilities in every state and each local community across the country. [xxxi]

ADULT FOSTER CARE

When developmentally disabled citizens became an active part of the community, one of parent's greatest concerns were, "What would happen to them once parents were deceased." Margaret was especially troubled. "Just what happens to my child when I pass on? Why was it so wonderful putting them out in the community? Where do we go from here?" These questions were addressed in a discussion group at 24th Annual Conference of The Michigan Association for Retarded Citizens (MARC) held June 25-28, 1975 at Sugar Loaf Village, Cedar, Michigan that Margaret attended. The meeting was conducted by Dr. Seevers, Ph.D., President, National Conference of Executives of Associations for Retarded Citizens and Executive Director, Elkhart County, Indiana Association for the Retarded. Margaret was an active member of this association and took the state senator to lunch with Irene one day. They also met with Governor George Romney. Margaret and Irene took turns attending. They would trade off child care so both could attend. xxxii

They went through The Michigan State Development Authority to get approval for a brand new facility for adult foster care. Judge

Horn assisted Irene in the beginning of the project. When he passed away, Judge Burke McClintock continued. Ed Lynch, lawyer, Don and Peg Gillis, Duane P., Margaret McQuiston and others sat on the board. When they tried to get the mortgage, it took an act of God to get approval. They couldn't have done it without his help. Irene worked on the project for four years when an attorney friend, John Devine moved into town. She visited him and said, "John, I have a project and need an attorney. I've been working on this for four years and need someone to help." It took John Devine, their lawyer, four additional years to get it approved. That included paperwork, negotiations with the state department, finding lots for the building, having the site approved, etc. Irene did a lot of work in getting the facility established. She made an appointment with a Michigan State Representative from Clare, Michigan. Irene was vice-chairman of his party, but his attitude toward their children wasn't good. When Irene spoke to The Board of Commissioners, they introduced her as, The retarded lady, and she said, "Well, you didn't miss it by far," and went right on giving her speech. Irene was anything but retarded and could speak with an eloquence and poise that put many to shame. She put them in their place and still got her point across. Irene could speak to a group of any size and was very persuasive in expressing her concerns to the public. She had a way with words that surpassed many. Her persistence in establishing a home for the disabled was inspiring. The results were even more encouraging.

PRAYERS WERE ANSWERED

Establishing Foster Care in Central Michigan was a long drawn out process. They broke ground with the first establishment in the area that took eight years and many prayers before the project was finally well under way. When things looked dismal and negotiations with the public just wasn't helping Irene would call Margaret and say, "We need prayers today, because I'm hitting a brick wall." A group of interested people united in prayer. Each of them called a list of concerned and caring people who would pray for help and before long, doors would open. It was God's will to have programs in Central Michigan that would provide for disabled citizens. It had to be! The people they called were members of The Parent's Association with various religious affiliations. Elaine G's grandmother was Catholic and she prayed all day, starting out with the rosary. Some were Jewish, Margaret was Methodist, her sister's were Christian, but attended different churches. It didn't make any difference what religion they were. Margaret would say, "I'll call Wilma." Each person they called had a list they called in turn.(people refer to it as a prayer chain). The people who lived in Whispering Willows Apartments and Margaret's sisters would

pray with them. Whenever prayers were needed, this group of people united together. There is no doubt the wonderful foster care program was established through prayer. They both gained a testimony of how God was watching over the work and touching hearts of influential people to soften their hearts. Hard work, prayers, dedication, and persistence finally paid off in the end.

SALLY'S FATHER PASSED AWAY

When our father Merrill died from a heart attack in his home in 1979, they lost a wonderful husband and friend. Irene went to visit Margaret and said, "Oh, I didn't think we would ever have to share this." They held hands and cried together. All the disabled knew Merrill and wanted to come to his funeral, so Irene brought them. Normal people may forget, but these people don't forget you. He would do anything for them and had a friend from Shepherd who came and worked right along beside him on the projects.

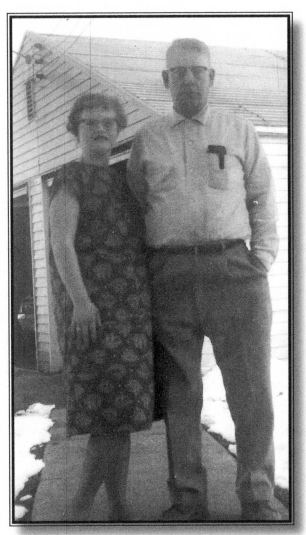

Sally with Her Father, Merrill McQuiston

SALLY'S CONCERNS ABOUT DAD'S DEATH

Sally missed Dad terribly and had a hard time adjusting. Sally was so troubled that Reverend Ron Vredeveld was asked to counsel with her and see if he could give some comfort. It was Reverend Ron's first association with the disabled, so he had a hard time understanding what Sally was talking about at first. He met with Sally for a half hour once a week for a long time. After several of these counseling sessions he was able to understand why Sally was so fearful. Sally was living with her parents, Margaret and Merrill McQuiston, in their home when Merrill died. Sally had vivid memories of him, going to his funeral, going to the grave site, and the events that took place. Margaret took a lot of medications for health problems and Sally was scared that she would die, also, and Sally would be left alone. Sally was involved with Mid-Michigan Industry, but lived at home with her parents.

Reverend Ron Vredeveld talked to Margaret at length about how important it was for Sally to be placed somewhere she would have care in case of Mom's death. The decision was an extremely difficult one for Margaret to make, but she was finally convinced it

was in Sally's best interest. Reverend Ron Vredeveld continued to be involved with Sally's counseling and adjustment. He said Sally adjusted quickly and being there was definitely the right thing to do. However, letting go was a big adjustment to Margaret.[xxxiii]

Knowing Sally had a home to live in when Margaret passed on was a great comfort and helped ease her fears about Sally's future.

ASSOCIATION OF INTER-FAITH MINISTRY

An idea began in 1978 when people from a Catholic church and a Lutheran church came together to share their thoughts and form a committee to provide consistent religious worship to residents of the Mt. Pleasant Regional Center for Developmental Disabilities. Reverend Ron Vredeveld, coordinator of religious services for the Association of Inter-Faith Ministry worked to develop an outreach to disabled citizens.

Sally attended worship services with The Association of Inter-Faith Ministry, which started so people living outside an institution could attend church. Sally was the first individual in this unique group Reverend Ron Vredeveld associated with. Communicating with her was challenging at first, but barriers broke down and he became very concerned and interested in those with disabilities. This spoke well for the religious communities. What compassion and open hearts they had! It started with residents of The Mt. Pleasant State Home and Training School, including "The Day Center" group, and grew from serving 17 students in 1980 and served 110 students in 1986, to serving over 400 in 1995. There

were a total of 19 churches involved in AIM-DD (Association of Inter-Faith Ministry - Developmentally Disabled). This expanded into different churches and religions, so it varied with each denomination. The friendship class church service was held on Sally's level with other disabled individuals. They would sing, pray, have lessons and held socials once a month. Families came to dinner and they celebrated together. Reverend Ron Vredeveld, coordinator of religious services for AIM-DD was a large part of this successful outreach. The ministry offered a Christian education to persons who live in their own homes or group homes in the community. It was a bridge for developmentally disabled people to become part of society. The Sunday service was modified to fit the level of understanding developmentally disabled people needed. It grew very successful. In addition to classes, a Sunday morning service was conducted every week at The Mt. Pleasant State Home and Training School. The ministry offered a Christian education to persons who live in their own homes or group homes in the community. An important part was the universal language of music. If you don't understand the words you can respond to the sounds, Mr. Vredeveld said. Margaret Vredeveld developed a music model that is used for other groups. Representatives from the Christian Reformed Church Publications, publisher's of the Friendship Services curriculum used in AIM-DD selected her model for the friendship Series curriculum. [xxxiv]

SPECIAL EDUCATION PROGRAMS IN THE UNITED STATES BECAME MANDATIORY IN 1975

Special Education became mandatory in 1975 when the United States Congress passed the <u>Education for All Handicapped Children Act</u> (EHA) in response to discriminatory treatment by public educational agencies against students with <u>disabilities</u>. The EHA was later modified to strengthen protections to people with disabilities and renamed the <u>Individuals with Disabilities Education Act</u> (IDEA). The federal laws require states to provide <u>special education</u> consistent with federal standards as a condition of receiving federal funds.[xxxv]

Education to the public school campus, if at all possible, was limited until the passage of PL94-142 in 1975, American schools educated only one out of five children with disabilities.[xxxvi]

CLARE-GLADWIN USES SPECIAL ED GRANT

- Headlines report on a federal grant for special education being utilized by both Clare and Gladwin counties to prepare pre-school children for school. Students in Clare, Farwell, Harrison, Beaverton and Gladwin were eligible for the program. Preschool sessions lasted three hours each week day morning. Project Child Find helped to identify children who needed extra help. Today we take such services for granted. In 1978 it was the exception, not the rule. The program was funded by federal program PL94-142, a federal law mandating free and appropriate education for all handicapped children aged 3 to 21.[xxxvii]

People like my mother Margaret McQuiston and Irene Otteman were instrumental in establishing Parent's Association gatherings helped fight for this educational opportunity that was approved in the 1970's. They moved forward with their unending quest to make better lives for others.

JOHN DEVINE, ATTORNEY

Sometime in the summer of 1978 they formed Central Michigan Non-profit Housing, Inc. and construction of Devine House on McVey Street started. It took at least two years with completion in 1980. Summers of 1976 and 1977 John worked in an office located in an Insurance Agency office, developing his law practice. Irene asked him to help with building a house for the disabled. That's when and how they started and her first contact with John Devine as an attorney. She was a family friend as well. When Irene enlisted his help she had been working on the project four years. It took another four years including paperwork, negotiations with the state department, finding lots, purchasing the site and approval.

They started with a **501(c)(4)**, classification with the IRS and became a tax deductible corporation. It was untested territory for both of them, but they forged ahead and were accepted. They couldn't build a house until a mortgage was in place with Michigan State Housing Development Authority or MHSDA. That began a fairly lengthy and arduous process of dealing with MHSDA and made out an application. They had to raise $15,000 in the beginning (calculates to $57,729.96 in 2014).

The loan was $460,000 (calculates to $1,770,385.49 in 2014)

They spent almost $470,000 (calculates to $1,808,872.13 in 2014).

It was essential to enlist local business donations and help. Local citizens had bake sales, garage sales, fund raising and all sorts of assistance. Once they met $15,000 MHSDA started to take them seriously. They had to have funds, so followers went to Lansing with them to show support. The mayor, newspaper reporters, Businessmen, parents of disabled, etc. went along to demonstrate they had backing. They reached a point where they were going to approve it and spent $470,000 total for the complex. They had to have plans, blueprints, a budget, etc. so it took almost two years getting it in place. Paperwork and plans went back and forth to Lansing numerous times until approval finally came.

Irene wanted to name the facilities Happiness House, but the officials wouldn't approve the name. Irene proudly said, "John has done a lot of work, we're going to call it Devine House." The people in Lansing said, "You can't name it after him because he's not dead." Irene said, "We're going to call it Devine House. You can call it anything you want to." John would have preferred it named after Irene's son. A tremendous amount of paperwork went back and forth. Officials wouldn't call it anything but derogatory Mt. Pleasant Mental Retard 512. All paperwork from them had that label. John and Irene wrote back and called it Devine House. MHSDA called it Mt. Pleasant Mental Retard 512. They responded with correspondence calling it Devine house over and over. This went on for about eight months before MHSDA accepted the name. Finally they received budget approval from MHSDA in a leather bound jacket with the name Devine House boldly printed on the cover.

They had the choice of an "A" contract with MHSDA where they got a budget annually and accounted for everything they

spent. John and Irene chose an "A" contract, and never made a nickel on the project. It was for the benefit of people involved not for personal gain. They didn't want to make a profit for themselves.

The "B" contract would give them $200,000 ($769,732.82 in 2014) to spend whatever way they wanted. Many people took advantage of this, and whatever they didn't spend they kept as a profit. Irene and John did not want to make money. Their motivation was to help the disabled. Many people chose the "B" contract and have become wealthy.

They opened up business and it was a great success. Irene and Floyd Otteman lived in the apartment and took care of the disabled. Others lived there at different times to oversee the residents, as well. [xxxviii]

The first building for developmentally disabled was located on McVey Street in Mt. Pleasant, Michigan and was a one story structure that opened up in 1980. Pam Lewandos was the first program coordinator for Devine House 1 (1980-1982) When it opened Sally had her own room. The timing was right, because Sally's father died in 1979 and Reverend Ron advised Margaret to let Sally live in a more independent lifestyle. Sally adapted to the change well, but Margaret had a harder time adjusting.

Sally enjoyed going home to visit Margaret, but wanted to be back in her own place when night time came. It truly became her haven and she was given the opportunity to interact with others like herself that could be given in no other way. She enjoyed the parties, annual prom, bowling, dances, field trips, circus adventures, Halloween parties, Valentine's Day parties, Christmas parties, concerts, fishing trips, trip on a Charter Bus to the legendary Grand Ole Opry in Nashville, Tennessee where you are assured a show with fantastic country music

It also gave Margaret a sense of security knowing Sally would have a home of her own once she passed on. Her health was

declining and Sally was worried about what would happen to her if mother passed away. It also gave them both a new found freedom to structure their own time and lives in a different way.

Shortly after Irene started McVey house, they started Devine House II for Prader Willi Syndrome residents. The second house was built a block away from Devine House I on the corner of Johnson and McVey. Devine House III was built in Winn. Then they bought a house in Blanchard for Devine House IV. All of these homes were for Developmentally Disabled/ Mentally Challenged people. Apartments on Broomfield Road where Sally lived was the last place called Devine Living Center, Supervised Apartments. It was for those who were able to live in a more independent living lifestyle.

"Construction on Apartment Complex Starts" article shows a picture of Irene Otteman and John Devine, Attorney where they plan to construct a 24-person apartment complex for developmentally disabled individuals. The apartments were a co-venture of Otteman and Mt. Pleasant Attorney, John Devine, who own and operate four foster care homes for the mentally disabled in Isabella County. It was one of the first complexes in the state where developmentally disabled would have their own dwelling, complete with bedrooms, bathrooms, living rooms and kitchens, according to the article. It was located on Broomfield Road and would be called Broomfield Assisted Living Apartments.[xxxix]

Sally became one of the first residents of the high functioning supervised independent living complex when it opened. Margaret's training for Sally proved invaluable. Sally adapted quickly and was one of the first to go into the community as a worker for a local motel, where she cleaned rooms, made beds, and prepared rooms for public use. She had her own apartment shared with another resident and lived there until her health required a move back

to Devine House 1 on McVey Street, Mt. Pleasant, because she became medically fragile.

Residents receive Supplemental Social Security Income to pay for personal expenses. The facility's board of directors established a screening committee to review applications of prospective residents. All were moderately or severely mentally impaired and independently mobile.[xl]

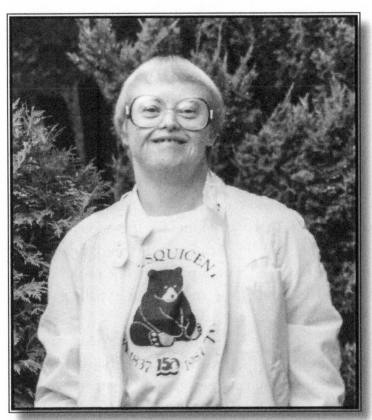

Sally - 1987

COMMUNITY SUPPORT

Margaret was on the board for Adult Foster Care, but she lived in Clare. Much community interaction came in Mt. Pleasant area, which was a larger community with contacts Irene had and where they would build a Foster Home for this special population of people. Joining Irene in pursuing community support for Adult Foster Care was Peg Gillis, a parent of one of the students[xli]. It took Margaret awhile to accept the idea of Sally going out into the community.

The Department of Mental Health was committed to placing residents of the state facilities in a least restrictive environment if possible, with a certain percentage of residents coming from state institutions, however, many of them would be from homes where they have been all of their lives.[xlii]

Irene and Peg reached out to the community and offered their speaking services to discuss the project with as many groups as possible. They lived in the Mt. Pleasant area and had hopes the disabled would be embraced by the public. However, they were never fully embraced by the general population, but formed their own separate support and comfort level of activities they can

participate in. Mary, her daughter remembers the way people used to stare at someone disabled. They do not look intently anymore, but are more tolerant, understanding and charitable.

The Knights of Columbus provided a down payment of $1,036.00 ($2,992.72 in 2014) for a much needed 12-seater van with proceeds from the "Tootsie Roll" drive on April 10-12, 1980.[xliii]

Being a part of the community is matter of fact these days. Other parents that were actively involved in the lives of their children were Dorothy S and Ann T.

BEST FRIEND'S

Irene and Margaret were best friends and experienced things nobody else shared. There was never any animosity, jealousy, or contention between them. As you look at their friendship and what they accomplished in fifteen years, it seemed as if they were destined to open doors and make it possible for an exclusive population of people to have a better life.

Irene appreciated the batch of molasses cookies Margaret made for her birthday every year until Mom's health failed and she wasn't able to walk due to crippling arthritis.

Irene visited her one day and Margaret couldn't get around very well. Irene made her bed and did a few things around the apartment. Margaret promised to call Irene if she could help, but Irene didn't hear from her.

When Margaret asked Irene to be Sally's guardian she answered, "Oh, Margaret, that is the nicest compliment anyone ever paid me. Of course, I will do it."

Margaret's grandson, was in Mt. Pleasant, Michigan purchasing a new tire for his pickup truck when he ran short of cash. He went to the local bank to apply for a loan and when he told them his

name the banker wanted to know if he was related to Margaret. When he said, "Yes," the banker reached in his pocket and gave him the $30 remarking how much Margaret had contributed to disabled citizens over past years. Her grandson walked away with the money and no loan to pay back. The show of respect for his grandmother was never forgotten.[xliv]

Margaret was always so independent. I wanted to purchase a nice gravestone for her only to find out she had one already chosen and paid for along with the casket and funeral arrangements. She was always so self-reliant even until the end of her life. I wanted her to come spend Christmas with us, but she refused to fly even though I had the tickets.

Fortunately, Sally and Irene's son were the last children in their family and they were able to devote considerable time doing the work. Their spouses were supportive, also. Irene talked about coming home late many evenings after working with committees or community organizations.

HANDICAPPED SENIOR FIGHTS TO PARTICIPATE IN COMMENCEMENT

Newspaper article talks about an Ohio high school senior confined to a wheelchair. School officials hesitated to let the handicapped teenager graduate with her class.[xlv]

Attorneys were representing the senior who has accused the school of discriminating against her because of a handicap.

This is just one more example of how far we have come today in accepting people who have disabilities of all kinds. Just one generation removed from Sally are Margaret's grandson's who remember taking her with them and her being acknowledged just like any other person would be. Things changed quickly once the transition was made from institution to community.

SPECIAL EDUCATION
MILLAGE OK'd

Voters in the Gratiot-Isabella Intermediate School District approves a .9-mill increase for Special Education. Publication was in 1987 and things were still changing for the disabled. Once laws were in place to provide for people with disabilities, things progressed for the good of those who needed it.[xlvi]

ORGANIZATION BEING FORMED FOR FAMILIES OF HANDICAPPED

A group of citizens in the Mt. Pleasant area is trying to organize the parents, families and friends of handicapped persons with either physical or developmental disabilities. Irene was trying to form a support group where people could meet and discuss their problems, needs and concerns.

Irene ran the Devine Houses, four adult foster care homes in Mt. Pleasant.

The project was discussed in May at the annual state conference of the State Association for Retarded Citizens in Lansing.

It was her hope "to get a day care center for disabled children of working parents." Such children need special care that most babysitters cannot give.[xlvii]

MARGARET'S DEATH

Margaret passed away in St. Luke's Hospital, Saginaw, Michigan on March 2, 1990 from complications of the flu, a bleeding ulcer, and diabetes. She was given honorable remarks from Mr. Lawrence Wyman, Sr. of Stephenson-Wyman Funeral in Clare, Michigan for her dedication, devotion, and help for developmentally disabled people. He was a member of the board who oversee the million dollar complexes now in place. When she came to his funeral home, he said, "Do you know who this is?" and began to tell others of the wonderful contribution she had made in her lifetime for developmentally disabled people. He shared this information with attendees at her funeral. Margaret never received monetary rewards for the work she contributed in their behalf. Her only interest was to help make a better life for those who had been forgotten or pushed aside by society.

She was a Board Member of Mid-Michigan Industries, United Methodist Women, Isabella County Association of Retarded Children, volunteer for Meals on Wheels, and Clare Senior Citizens.

She is buried in Surrey Cemetery, Farwell, Michigan beside her husband Merrill, Sally and three children who died in infancy.

When Margaret passed away Irene called the judges office and said, "Mrs. McQuiston passed away and I am Sally's standby guardian and must find out what to do." She was told that Margaret had all of it taken care of twenty years ago.

One of Mary's extremely touching memories of Irene that was when she retired as caretaker of the disabled. Irene was owner and administrator of Central Michigan non-profit Housing for 20 years. Mary decided to have a party for Irene and invite those who were interested in coming. This was arranged with the idea that Irene needed to slow down. The people that came to acknowledge Irene were numerous. They came from The Parent's Association, the community, her church, and organizations she was involved in. It was an emotional day for all of them and helped introduce Irene to the idea that perhaps it was time to "hang up the towel" and think about retirement.

Irene worked at the Mt. Pleasant Regional Center and had a long history of community service. She was voted Citizen of the Year in 1965. She was a 50-year member of the Presbyterian Church.

MT. PLEASANT CHAPTER OF MICHIGAN STEELHEADERS

Broomfield Assisted Living residents went on a fishing trip every year. Taking 40 to 50 people with handicaps fishing every year brings as many rewards for the Mt. Pleasant Chapter of Michigan Steelheaders as it does for those going fishing. "Originally, those who attended were students at Sunnyfield School, but it was later expanded to include residents of foster homes and independent living apartments," said Irene Otteman who runs homes for disabled in Mt. Pleasant.

The Steelheaders contact the state and get free fishing licenses for a day for those who want to fish. Some charter boat captains from Frankfort help take them out on Lake Michigan in boats that range from 20 feet to 38 feet in length. "We just thought it was a nice thing to do. Hey, they're not the only ones who have fun. We have fun, too. When they catch a fish, they go wild," a Steelhead member said.

Foster care homes provided transportation for their clients and put on a big picnic of hot dogs, potato salad and lots of other goodies after the fishing each day.

Otteman said Sally McQuiston caught the largest fish. About two years ago, another of her residents received a Master Angler award from the state for catching an 18 1/2 pounder.[xlviii]

INTEGRATION INTO
THE COMMUNITY

Margaret was so good with disabled people. She had the patience of Job and taught Sally to make a cake as good as anyone can, even though she cannot read a recipe. Sally could embroidery, do needlework of various kinds, craft projects, her own laundry, her own cooking, keep herself well groomed, and kept her apartment spotless. She was so clean. she brushed her teeth two or three times a day, always took a shower at night, does her own nails, and washes her hair. Her (ADL) Adult Daily Living Skills are so perfect that had to come from patience and love from Mother, her best teacher. Sally loved coffee and always offered it to anyone that came to visit her at the apartment.

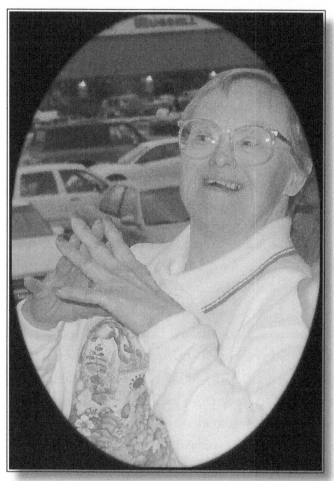

Sally On Chartered Bus Going to Grand Ole Opry in Nashville

Margaret worried about how the disabled would be treated in the community, but many were given an opportunity to work. Sally helped clean a local motel until she grew older and developed arthritis that made it hard for her. Sally was one of the first people at The Holiday Inn to work in the community. A small crew selected from the apartment complex on Broomfield Road went every day. Only those who were able to adapt and were more trainable were given this opportunity. Sally worked at the Central Michigan University cafeteria when her arthritis prevented her from doing physical labor. The residents were integrated into the community little by little and people knew who they were when they came into local stores. I went to Wal-Mart with her one day and she was greeted by someone who knew her. It was a pleasant greeting that helped me know she was accepted for who she was.

Sally kept her apartment clean and shining. She fixed her own breakfast and lunch and went to the large community room for dinner with the rest of the residents in evenings. They had dinner together, watched movies, made popcorn, cookies, treats and had a family life.

She had a heart murmur and was given a pacemaker that would last until a couple of years before her death. The heart grew less and less capable of pumping. At age forty-eight her memory was slipping and she showed early signs of dementia. A large percent of Down Syndrome people eventually get symptoms like Alzheimer's. It is just part of what they are genetically predisposed to and there seems to be a parallel between dementia and Down Syndrome.

She was beginning to not recognize people, but Marilyn was given a special gift from God when she came to visit Sally. It had been a few years since they had been together and the drive from Chicago O'Hare Airport to Mt. Pleasant, Michigan was a long one, four hours, twenty-two minutes or 284 miles, but the

first person I wanted to see was Sally. Sally was sitting on her exercise bicycle on McVey Street when I arrived at her home. She recognized me immediately. Sally just hugged me, cried, hugged me again, and cried over and over saying, "I am so happy to see you." It was such a sweet reunion. She didn't recognize Linda who came to see her every week, but Sally did have a small window open up where she recognized Linda before Sally's death. Linda and her brother Larry saw her frequently and always made Sally a part of their holiday celebrations. Margaret's sisters usually visited her. She remained a part of the McQuiston family who will always be cherished and remembered for the countless lessons we learned from her presence.

Her heart continued to fail and the pace maker wouldn't provide needed support to her any more. We siblings, Larry McQuiston, Linda (McQuiston) Dole, and myself, Marilyn (McQuiston) Graham did not want to put her through another surgery for a new pace maker when she was so fragile. She had lived a wonderful life and fulfilled her purpose on earth. It was time to be with Mom and Dad once again on the other side of the veil in heaven.

When Sally's heart grew weaker Linda and Larry were attentive. When hospice came in,. Reverend Ron Vredeveld from Inter-Faith Ministries sat at her bedside often. He also spoke at her funeral, as they had been friends for many years. She stayed at Devine House on McVey Street during hospice care and other residents came to visit her. They understood what was happening and cared for her deeply. She had her new found friends and biological family. Reverend Ron still speaks at many funerals for the disabled population. He said there is a remarkable difference between funerals for those living in the community versus ones that were confined to institutions all their lives. At Sally's funeral a lot of people came. Family members, people in the community,

residents of Devine House, and friends of the family. They were teaching people the value of life regardless of their circumstances.

One memory in particular came to mind where he went to a funeral where only three people were present. Himself, the guardian and funeral director. That person had no family members keeping in touch.

Another case was when a brother of the deceased showed up at the funeral not even aware his own brother existed in an institution. His wife read about it in the newspaper obituary and he showed up to show respect and honor his brother. There were about 25 people present.

Parents often never mentioned it to the siblings once the child was institutionalized. "When they lived in centers, nobody would attend funerals, because their life wasn't considered of value and nobody knew them."[xlix]

Having a place like Devine House gave Sally and others like her a place to live once their parent's passed away. Irene was her guardian when Margaret died until Irene passed away. Then Irene's daughter, Mary Fussman became guardian until Sally's sister, Linda (McQuiston) Dole moved to Clare County, Michigan. Linda became her guardian until Sally's death in 2007. Sally lived to be 58 years old.

Linda cared for the elderly 9 or 10 years at Harbor Springs Michigan Care Facility. She then worked at a factory in Boyne City until they shut down. She saw an ad in the local newspaper looking for help with the disabled and they hired her. Her experience working with elderly, a disabled sister with Down Syndrome, and knowing her mother had started programs in Central Michigan, was what persuaded them to hire her. Linda worked for Northern Michigan Community Mental Health Workshop (WDW) near Boyne City, Michigan for 9 or 10 years. The name has changed, but it still exists today and some of the residents and former

employees visit Linda. The majority of residents she worked with have passed away now

Sally lived in a Group Home near Traverse City in Kingsley, Michigan for a short time when residents were placed into the Community. Linda visited her occasionally and took her to visit Mom and Dad from time to time. Linda thought it was a good place, but Mother wanted Sally closer to home and Sally didn't stay there long.

Linda feels good about the disabled being placed in a community. Planned activities give them constructive things to do, they had staff with them when out in the community, going on nature hikes, shopping, going to garage sales where they would have some money and could buy something on their own or enjoying fun recreation together. Community members respected the residents and they respected the community.

Mary Fussman, Irene's daughter still works at the McVey Street building. My conversation with her in 2014 assured me that both programs are still functioning well, and the developmentally disabled individuals receive good care. All of Mary's children have worked in the homes in some capacity. The special population of people it houses are accepted by the community as well as could be expected. They have never been fully embraced by the public, as Irene Otteman and Peg Gillis dreamed they would, but they have their own unique activities designed just for them.

HOW SALLY INFLUENCED MY LIFE

People have asked me how Sally's life influenced mine. It Is hard to describe the incredible things I have gained because of her presence. There were also difficulties to overcome that the normal family does not have to face.

All of our family had a deep love for Sally and even our aunts, uncles and cousins felt the same way. She was a choice spirit sent here on earth for a purpose.

I was next to the oldest child in our family and a real protector of my siblings. If anyone hurt them, it hurt me deeply as well. I am still a warrior against persecution and adversity.

The fact that the word "retard" and "retarded" was used frequently and openly pierced my heart and soul. Thanks to deeper understanding, that word is not used today. My lack of confidence and shyness brought a feeling of loneliness and emptiness. Perhaps it appears as aloofness or a coolness to others when the feeling is really a protection from the isolation and rejection I felt from others when younger.

Life is hard for any teenager, but having a peer group withdraw their friendship from me more than once had an consequence.

That and my extreme shyness had negative results. I became more isolated and built walls around myself. Even today I find myself drawing back from people at times and not letting them penetrate the protective walls. There are only a few close friends in my life who those walls went down for. My best friend through high school was Christine C. We still keep in touch and I consider her a lifelong friend. She lived out in the country near my cousin Glenda A and I felt comfortable with that group of people and associated with them. However, Christine was my best friend and is still loyal to me. She was one of the few people I invited into our home for a sleep over. Christine seemed to understand me and knew Sally. I was Christine's wedding attendant when she married. Another friendship I developed during my high school years was Carlisle G who I walked downtown with after school. He worked in a small grocery story on Main street and I worked at the local pharmacy. He seemed to accept me unconditionally.

I always enjoyed playing softball during recess during grade school and gym class in high school. It gave me a feeling of being okay in the world. My ability to play softball where I could pitch and hit fairly well brought recognition from my peers. My ability to play volleyball also made me feel good when the other students cheered me on against an opposing team. It was a form of recognition that gave me self-satisfaction.

I loved dancing when our gym teacher gave us the opportunity and never understood why some people hated class and said they were sick and didn't participate.

I was an excellent swimmer due to being raised on a small inland lake in Michigan.

I could sew my own clothes and even made my own prom dress one time. It was white satin overlaid with white nylon netting and tiny turquoise bows.

My sister, Janet had a clarinet and was in the band one year before my parents purchased a saxophone for me. I got to go on a trip to Mackinac Island, Michigan with the Harrison band before moving to Clare, even though I was not a band member yet. It was a great day of fun and friendship.

I only had my saxophone about three months when we moved to a new school in Clare and I was put in the senior band. That was a huge mistake and disadvantage for me and I was a dismal failure. Finally, the band instructor told me to take the saxophone home and practice every night until I learned how to play or he would have to dismiss me from the band. I agreed to work on it and was able to overcome the unfavorable situation I had been thrown into. I moved forward with conscientious effort and received ribbons, awards, and participation certificates through the rest of my school years and became a solid contributing band member.

When our new instructor took over the band, it was pretty pathetic and diminished. However, he built it back up and I had an opportunity to played the oboe during concert season. That was a real pleasure as I loved the melodic oboe sound and playing solos during concerts. I continued with the saxophone during football seasons. I could listen to a symphony and recognize every instrumental sound.

However, I remained aloof from my peers.

I like to think the adversity and challenges I faced as a youngster help me endure hardships with tenacity and courage.

One quality I have developed through the difficulties of growing up under adversity is compassion for others. As a young lady in high school I had the opportunity to volunteer at "The Day Center" occasionally and help tutor students. It gave me an understanding of their personalities, which were very individual just like usual people. I once felt it would be rewarding to teach

handicapped individuals as I developed a deep empathy for them and the daily challenges they face.

My life changed after marriage and becoming a mother, and the dedication it took to raise four sons took all my energy.

I am perceptive to others feelings and in tune with their difficulties. It has given me the ability to help them with consideration and understanding.

I recently visited Devine House on McVey Street in Mt. Pleasant and the complex on Broomfield Road. Everyone who knew Sally remarked how much they loved her and what a sweet, nurturing, caring person she was. I always felt the same way.

I lived on the other side of the United States but always kept in touch with Sally by sending letters each week, telling her about my life, our lovely garden with beautiful flowers and vegetables, and the activities we took part in. Her care givers would read the letters to her and she had them mail one to me. Sally was the spokes person and the care giver wrote the letter. I still have it tucked away in my files. She was always a deep part of my heart and always remains there. I look forward to seeing her when we unite again after the resurrection and her body will be perfected with all the handicaps and disabilities gone. I believe she will have a beauty that will surpass others and that she was a exceptional spirit sent here to gain a body and help bring perfection to the souls of those who knew her.

I believe my mother, Margaret (Dunkle) McQuiston, was chosen to raise her and bring about the programs and meet needs for that special population that were lacking to further the work of the Lord in that part of the country, so those souls who were locked up in institutions could be recognized as a part of society and have quality lives.

How shocking their lives were before society opened their hearts to greater compassion and understanding.

We have come so far in this country in recognizing and meeting individual needs for disabled individuals. The difference in attitudes my nephews and Irene's grandson expressed have come a long way. Today others value qualities more than differences. May we still open our hearts to the disabled and realize the considerable significance of their lives.

LAPEER STATE HOME
AND ASYLUM

The Michigan Home for the Feeble-Minded and Epileptic opened in June 1895.By 1976 there were about 1,500 patients. It is closed now.[1]

THE COLDWATER REGIONAL
MENTAL HEALTH CENTER

The Center opened in 1874. In 1986 its name changed to Coldwater Regional Mental Health Center. It closed in June 1992.[li]

i	Edna Massimilla, Author of "Heaven's Very Special Child & the Family"
ii	Wikipedia, Encyclopedia
iii	Dr. Tim Otteman, CMU Professor
iv	thecountypress.mihomepaper.com
v	Recorded conversation with Irene Otteman
vi	Recorded conversation with Irene Otteman
vii	Recorded conversation with Irene Otteman
viii	Recorded conversation with Irene Otteman
ix	Recorded conversation with Irene Otteman
x	Recorded conversation with Irene Otteman
xi	Daily Times-News April 9, 1973
xii	Daily Times-News, May 31, 1973
xiii	Recorded Conversation with John Devine, Attorney Sept. 2014
xiv	Daily Times-News, April 9, 1973
xv	Daily Times-News, April 9, 1973
xvi	Daily Times-News, Thursday, May 31, 1973
xvii	Dr. Tim Otteman, CMU Professor
xviii	Dr. Tim Otteman, CMU Professor
xix	http://www.themorningsun.com
xx	Recorded conversation with Irene Otteman and recorded conversations with Margaret's grandchildren
xxi	Certificates in possession of Marilyn (McQuiston) Graham
xxii	The Morning Sun, Dec. 6, 1978
xxiii	Clare Sentinel, January 12, 1972 edition, pages four and six
xxiv	Morning Sun, Dec 26, 1980
xxv	Bob Banta former DJ and Deputy Sheriff
xxvi	Bob Banta former DJ and Deputy Sheriff
xxvii	Certificate in possession of Marilyn (McQuiston) Graham
xxviii	Alan Schilling, President of Mid-Michigan Industries
xxix	Morning Sun, Dec 26, 1980
xxx	Alan Schilling, President of Mid-Michigan Industries and www.mmionline.com
xxxi	WWW2.edu.gov
xxxii	Article of Margaret McQuiston and Conversation with Irene Otteman
xxxiii	Recorded conversation with Rev. Ron Vredeveld, Sept 2014
xxxiv	Morning Sun, May 24, 1986 Rev. Ron Vredeveld
xxxv	Wikipedia, The Free Encyclopedia
xxxvi	www2.ed.gov/policy

xxxvii Morning Sun, November 20, 1978

xxxviii Recorded Conversation with John Devine, Attorney, Sept 2014

xxxix The Morning Sun, May 5, 1989

xl The Morning Sun, 1978

xli The Morning Sun, Groundbreaking Ceremony Picture

xlii Newspaper clipping, December 6, 1978

xliii The Catholic Weekly showing van and KC Council

xliv Recorded Conversation Sept 2014 with Jeff McQuiston

xlv Morning Sun, Monday, June 1, 1987

xlvi Morning Sun, May 20, 1987

xlvii Morning Sun, June 24, 1987

xlviii Isabella County Herald, July 6, 1992

xlix Conversation with Reverend Ron Vredeveld, Sept. 2014

l Wikipedia, Free Encyclopedia

li www.asylumprojects.org/index.php?title=Coldwater_State_Home
Coldwater Regional Mental Health Center

Made in the USA
Las Vegas, NV
21 February 2023

67847030R00083